NEW YORK REVIEW BOOKS
CLASSICS

THE CRIMINAL CHILD

JEAN GENET (1910–1986) was born in Paris. Abandoned by his mother at seven months, he was raised in state institutions and charged with his first crime when he was ten. After spending many of his teenage years in a reformatory, Genet enrolled in the Foreign Legion, though he later deserted, turning to a life of thieving and pimping that resulted in repeated jail terms and, eventually, a sentence of life imprisonment. In prison Genet began to write—poems and prose that combined pornography and an open celebration of criminality with an extraordinary baroque, high literary style—and on the strength of this work found himself acclaimed by such literary luminaries as Jean Cocteau, Jean-Paul Sartre, and Simone de Beauvoir, whose advocacy secured for him a presidential pardon in 1948. Between 1944 and 1948 Genet wrote four novels—*Our Lady of the Flowers*, *Miracle of the Rose*, *Funeral Rites*, and *Querelle*—and the scandalizing memoir *A Thief's Journal*. Throughout the 1950s he devoted himself to theater, writing the boldly experimental and increasingly political plays *The Balcony*, *The Blacks*, and *The Screens*. After a silence of some twenty years, Genet began his last book, *Prisoner of Love* (available as an NYRB Classic), in 1983. It was completed just before he died.

CHARLOTTE MANDELL has translated nearly fifty books from the French, including works by Guy de Maupassant, Marcel Proust, Maurice Blanchot, Jonathan Littell, and Mathias Énard. She has been awarded a translation prize from the Modern

Language Association and the National Translation Award in Prose. Her translation of *The Magnetic Fields* by André Breton and Philippe Soupault will be published by NYRB Poets in 2020.

JEFFREY ZUCKERMAN's recent translations from the French include Ananda Devi's *Eve Out of Her Ruins* and *The Living Days*, the diaries of the Dardenne brothers, and the short stories of Hervé Guibert. He is the digital editor of *Music & Literature*, and his writing and translations have appeared in *Best European Fiction*, the *Los Angeles Review of Books*, *The Paris Review Daily*, *Tin House*, and *Vice*.

THE CRIMINAL CHILD

Selected Essays

JEAN GENET

Translated from the French by
CHARLOTTE MANDELL
and JEFFREY ZUCKERMAN

NEW YORK REVIEW BOOKS

New York

THIS IS A NEW YORK REVIEW BOOK
PUBLISHED BY THE NEW YORK REVIEW OF BOOKS
435 Hudson Street, New York, NY 10014
www.nyrb.com

Library of Congress Cataloging-in-Publication Data
Names: Genet, Jean, 1910–1986, author.
Title: The Criminal child : selected essays / by Jean Genet ; translated by Jeffrey
 Zuckerman and Charlotte Mandell.
Other titles: Enfant criminel. English
Description: New York : New York Review Books, [2019] | Series: New York
 Review Books Classics
Identifiers: LCCN 2019013970 (print) | LCCN 2019017486 (ebook) |
 ISBN 9781681373621 (epub) | ISBN 9781681373614 (alk. paper)
Subjects: LCSH: Juvenile delinquency.
Classification: LCC HV9071 (ebook) | LCC HV9071.G413 2019 (print) |
 DDC 364.36—dc23
LC record available at https://lccn.loc.gov/2019013970

ISBN 978-1-68137-361-4
Available as an electronic book; ISBN 978-1-68137-362-1

Printed in the United States of America on acid-free paper.
10 9 8 7 6 5 4 3 2 1

CONTENTS

THE CRIMINAL CHILD

To Évelyne

RADIODIFFUSION Française offered me time to speak on its program Carte Blanche. *I agreed, with the aim of talking about criminal childhood. My text, which was originally accepted by M. Fernand Pouey, has now been rejected. Rather than any pride, I only feel a certain shame. I had hoped that the voice of a criminal might be heard: not in complaint but in exultation. What impels me is a pointless need for honesty, honesty not so much in matters of fact as in obedience to the somewhat ragged tones of voice in which I express my feeling and truth, the feelings and truths of my friends.*

Already the papers are furious that a thief—and a homosexual—should be granted a public forum. So I am no longer allowed to go on-air before the nation. Again, I am ashamed. However much I had been in darkness, I was close to daylight, and now I am slipping back into the shadows from which I had struggled so mightily to escape.

The speech you are now reading was written to be heard. I am publishing it despite that, despite having lost hope that it will be read by those I love.

On-air, I wanted this to be preceded by interrogations, conducted by me, of a judge, a prison warden, and an official psychiatrist. All three refused.

<div align="right">J.G.</div>

I HOPE you'll understand and forgive the emotion I feel as I tell you about an adventure of mine. As you are a mystery to me, I must confront you with, and reveal to you, the mystery of prisons for children. Scattered throughout the French countryside, often in the most elegant places, are sites that for me hold inexhaustible fascination: those correctional institutions now officially, and rather genteelly, given such names as Moral Rehabilitation Facility, Reeducation Center, Home for the Rectification of Delinquent Youths, etc. These changes of name are not insignificant. "Reformatory" and, sometimes, "Penitentiary" had become something like proper names or, more specifically, had come to name the purest, cruelest places in the depths of a child's heart, and now educators have drained as best they could these names of their violence. But it is my hope that, despite the pitifully hygienic character of these new names, children will secretly continue to be drawn to the lure of "Penitentiary" and "Prison,"

even though these now exist on a moral plane rather than as a given space. How foolish to have tried to attack an idea by changing its name when the thing named is, if I may go so far, alive, set in motion solely by the actions, solely by the comings and goings of that most fruitful element: delinquent children. Criminal children. I want to repeat that the reflection or, rather, the image of these places whose names I've recited above blaze in the souls of such children. I will come back to this.

Saint-Maurice, Saint-Hilaire, Belle-Isle, Eysse, Aniane, Montesson, Mettray: these names may not be meaningless to you. In the eyes of children who have committed a crime or offense, they embody all that, for a definite stretch of time, lies in store for them.

"They've sentenced me to the twenty-one," they say.

These children are committing an (intentional) error, the tribunal having passed a judgment such as: "Acquitted for having acted without full awareness, and entrusted to the reformatory until the age of majority…" But the young criminal immediately rejects the indulgence and concern of a society that he has, in committing his first offense, revolted against. At fifteen or sixteen or earlier yet, he has attained a maturity that others may not reach even at sixty, and he scorns their munificence. He insists that his punishment be unsparing. He insists that the terms of his sentence manifest decided cruelty, and when he protests that it is they who have acquitted him, they who have handed down so mild a punishment, he does not say so without shame. He wants severity. He insists on it. Deep down he dreams of this severity as a terrible hell, of the correctional facility as a place from which he will never come back. And it's true, nobody ever does come back. Those who emerge are changed. They've

gone through the flames. And the names mentioned above aren't mere names: they're charged with meaning, burdened with a horror that the children embrace, for these names serve as the proof of their violence, their vigor, their virility. It is this severity that these children will conquer, and they insist on being tested terribly. The better to finally exhaust their restless hunger for heroism.

When I was a child, Mettray was one of the most prestigious names. But Mettray has gone to seed at the hands of some softhearted imbecile, and it is now, I gather, an agricultural colony. It was a harsh place back then. Upon arriving at this fortress of bay trees and flowers—Mettray wasn't walled off—the young outlaw, henceforth to be known as a colonist, underwent a thousand ordeals that would prove his true criminality. He was locked up in a cell that was painted all in black (even the ceiling). He was dressed in a outfit that for miles around was a symbol of the dreadful and ignominious. And as long as his confinement continued new ordeals lay in store for him: fights, sometimes deadly, that the guards let run their course; dormitory hammocks; enforced silences during work and mealtimes; bizarrely intoned prayers; barracks punishments; clogs; burned feet; forced marches under the noon sun; mess tins of cold water; and so on. We suffered all that at Mettray, and these miseries were echoed a hundredfold by the tortures of the Belle-Isle well, and, in other colonies, of the pit, the grave, the empty mess tin, the barracks, the latrines, and solitary confinement.

Schools at every level impose discipline in ways that strike a gentle soul as severe and pitiless. But school, it has to be said, is not made *by* children but *for* them. Penitentiaries, by contrast, serve as the physical embodiment of the hunger for severity that the young criminal secretly harbors. I do not

wish to blame the prison directors or prison guards of the past for the cruelties I've listed; they were nothing more than attentive, ferocious witnesses, cast in a self-consciously adversarial role. No, it is from the children's own passion for evil that these cruelties are necessarily born and develop.

(By evil, I mean the will and audacity to pursue a fate that is contrary to every rule.) The criminal child has forced open a door to a forbidden place, a door through which he hopes to enter the most beautiful landscape in the world: he insists that his penal servitude be unremitting. That it be worthy of *the evil he has brought upon himself* in order to conquer it.

For some years, well-meaning men have been trying to soften the situation. They want to win souls back to society. To return us to the straight and narrow, they say. Sometimes they succeed. But such reforms, thankfully, are superficial. They are merely formal.

What have they achieved? They've given a new name to the prison guards—monitors—and they've given them new uniforms so they don't look so much like prison guards. They've told them not to rely as often on physical or verbal violence; they're forbidden to hit us. Punishment is mild within the institution, and the so-called *reeducated* may even take up a trade. There's more freedom both in work and in play. The children are allowed to talk to one another. They're even allowed to talk back to the monitors and the director! Sports take pride of place. The Saint-Hilaire soccer teams play local teams and the players sometimes travel unsupervised from one town to the next. News from outside is permitted to enter the institution, though filtered and censored. The food is better. There's chocolate on Sunday mornings. And then, the crowning measure of these reforms: prison slang is prohibited. In short, the young criminals are allowed to

lead something close to the most ordinary of lives. That's called rehabilitation.

Society seeks to eliminate, or render harmless, the corrupting elements within it. It appears to want to narrow the moral distance between crime and punishment, or, rather, the narrow passage from the crime to the idea of punishment. This sort of castration is to be expected. It doesn't particularly bother me. It's true that the colonists at Saint-Hilaire or Belle-Isle might as well be at trade school, but still they never forget that the reason they are there, in that particular place, is thanks to evil. And because that reason remains secret, unspoken, it swells the desires of every child.

For the now-forbidden prison slang, the colonists substitute another subtler version, which, by a process I cannot describe on-air, approximates the prison slang of Mettray. At Saint-Hilaire, one of the colonists I had won over told me: "I said my friend ran away, but don't tell the director that I said he did a deer."

He blurted it out. At Mettray, we had used the very same words to talk about a kid who'd snuck out, saved himself, run like a deer in the woods.* I had been initiated into this secret language that was even cleverer than the one they were trying to stamp out, and I wonder whether it was being used to express thoughts and feelings that were all too carefully guarded. The educators were as naive as Salvation Army members, and as benevolent. At one institution, the director opened a desk drawer to show me a collection he was particularly proud of: some twenty knives that he had taken from the children.

*Editions subsequent to 1949 read "who the farmers had seen running into the woods like a deer."

"Monsieur Genet," he said, "the rules require me to confiscate these knives. And so I do. But look at them. Do you think they're dangerous? They're tin. Tin! You can't kill anyone with tin."

Did he fail to realize that, divorced from their practical application, objects are transformed into symbols? Their very forms change, become stylized. Their work is silent, cutting deeper and deeper into the children's souls. Buried in a straw mattress at night, or hidden in the lining of a jacket, or in pants—not for the sake of convenience but to be closer to the organ of which it is the essential symbol—they represent the murder the child will never actually carry out, even as they plant a seed in his dreams that drives him, I hope, toward the most criminal acts. Why bother to confiscate these knives? The child will choose some other, seemingly more benign object to represent murder, and if that, too, is confiscated, then he will safeguard a precious, perfectly precise image of the weapon in his mind.

This same director had allowed the most obedient children to form a team of scouts, and presented them to me. I saw a dozen shifty-eyed, ugly boys ensnared by good intentions. They sang ridiculous marching songs that couldn't hold a candle to the sweet or filthy laments sung at night in dormitories and cells. Looking at these twelve boys, I could plainly see that not one of them would ever have been picked or chosen to take part in any endeavor, real or imaginary, that would take true mettle. And yet, even with such educators, I have no doubt that there are still groups, gangs for that matter, deep within the penitentiary that are bound together by friendship, daring, cunning, insolence, incorrigible laziness, a gaze both somber and joyful, a taste for adventure that pits them against all the rules of the Good.

I apologize for such seemingly imprecise language. Keep in mind that my goal is to define a moral stance and justify it. My hope is to make sense of it and to use it against you. Aren't you, after all, the first to invoke "shadowy forces" or "evil's dark power"? You don't shy away from metaphors that serve your aims. But metaphors are more useful, I've found, for discussing man's dark side, which can only be explored, can only be understood through arming, anointing, embalming oneself with every ornament of language. But especially when you want to do Good—and see how easily I can distinguish Good from Evil even though such distinctions only matter to you, only after the fact, and yet I continue to address you, I do you that favor—if you try, as I said, to do Good, then you know where you're going and that it's toward the Good, that the outcome will be beneficial. When it's Evil, it's always hard to know what one is talking about. But I know that when I take up my pen to write, Evil is the only thing that loosens my tongue and that betokens where my heart's allegiance lies.

The truth is the only criterion I have for the beauty of an act, an object, or a being, is the song that it stirs in my soul and that I translate into words to share with you: this is lyricism. If my song were beautiful, if it moved you, would you go so far as to say that the man who sang it was vile? You might claim that there are words that have long been used to express the most exalted states, and that I am using those words so that the lowest of things may appear exalted. I might counter that my emotion rightly summons these words and they arrive quite naturally in its service. And so, if your spirit is base, go ahead and call whatever it is that drives a fifteen-year-old child to transgress or commit crime mere *heedlessness*; I will call that impulse by another name. Because

it takes nerve and guts to rebel against society in all its strength, against the harshest of institutions, against laws upheld by police whose power derives not only from organization but from the legendary, mythical, nebulous fear it plants in children's hearts.

A romantic fervor drives these children to crime; they project themselves into the most magnificent, daring, and ultimately dangerous lives. I am acting as their translator because they have the right to any language that will allow them to venture...where? you might ask. I don't know. Neither do they, however precise their fantasies, but it's nowhere you'd call home. And I wonder if it isn't perhaps vindictiveness that drives you to pursue them: because they scorn you, because they are leaving you behind.

I'm not offering you any solutions. From the start I have been speaking not to the educators but to the guilty. And I don't want to propose some new plan for the protection of society. I trust society: it knows perfectly well how to ward off that endearing danger, criminal children. It's to them I'm speaking. I implore them to feel no shame at what they've done and to safeguard the rebelliousness that has given them such beauty. I have to hope that there is no cure for heroism. But, be warned, you kind listeners out there who haven't already turned the dial, I want them to know they will have to suffer every bit of the shame and infamy inherent in this nobility they hunger for; they will have to swear to their being every bit of the bastards they are. These children will be cruel the better to sharpen the cruelty that makes their light shine.

Whoever seeks, out of benevolence or from privilege, to diminish or abolish rebellion destroys any chance of his own

salvation. And only those who have been found guilty of a crime and sentenced for it can forgive it.

Spontaneous aphorisms! The lyricism I spoke of before is certainly what inspires them. In uttering them, I rely on one principle alone: the pain it would give me to propose the opposite. What does your own moral compass steer you toward? Permit this poet and this enemy to address you as a poet and an enemy.

The only way the great and the honest can hope to preserve any moral beauty is by refusing any pity to the children who reject pity. And messieurs, mesdames, mesdemoiselles, you must not presume that it is enough for you to condescend to the criminal child, lavishing your attention, your concern, your indulgence upon him in the belief that he will respond with affection and gratitude: for that you will have to be the child and you will have to be the crime as well, hallowing it through a magnificent life, through daring to liberate yourself from worldly powers. Since we are divided—since some of us have shown such desire and daring—divided between the not-guilty (I won't say innocent), between you, the not-guilty, and us, the guilty, remember that all your life you've lived on one side where you presume yourselves at no risk whatsoever, where you can even feel Good, extend a hand to shake. I've made my own decision, however: I'm on the side of crime. And I'll help these children, not to return to your houses, your factories, your schools, your laws, and your sacraments, but to steal them all. And yet perhaps I can no longer lay claim to such virtue! Perhaps it wasn't simply by mistake that I was allowed so readily to go on-air.

In the papers there are still photographs of corpses: silos overflowing with them; fields strewn with them; corpses

caught in barbed wire; corpses in crematory ovens; torn-out fingernails; skins tattooed and tanned for lampshades. These are Hitler's crimes. Nobody, however, seems to have the least idea that, in prisons for children, in the prisons of France, for ages now, children and men have been tortured. It makes no difference that in the eyes of justice, human or divine, some are innocent and others are guilty. To the Germans, the French were guilty. We were so badly treated in prison, with such cowardice, that I envy you your tortures. We suffered like that, but you suffer so much better. A plant needs heat to grow. The bourgeoisie sowed the seed: the prisons of stone, with their physical and spiritual guardians. How I rejoice to see the sower devoured at last! These nice, good people—whose names are now gilded in marble—applauded when they saw us handcuffed and shoved in the ribs by the cops. And the burning blood of those Nordic heroes has transmuted those cops' pokes into the most marvelously beautiful, tactful, and eloquent of plants, a rose that under a hellish sun unfurls its twisted petals of pink and red and bears horrific names: Maïdenek, Belsen, Auschwitz, Mauthausen, Dora. Well, I take off my hat.

But we will continue to serve as your conscience—for no other reason than to give our adventure yet more beauty, since we know its beauty depends on the distance that separates us from you, and because on whatever shore we happen to wash up, nothing, I am certain, will be any different. On your well-settled beaches, we will immediately recognize your small, slim, sullen selves, and we will know your powerlessness and your softheartedness. And yet you must rejoice. If it is those who are cruel and those who are wicked that you fight against, then we will be that force for evil. We will be that resistant material without which there would be no artist.

Romantic drivel, you say.

The truth, however, is this morality that leads you to hunt down children hardly carries any weight in your own lives. I don't hold that against you. The merit you have is in professing these principles that give some order to your life. But you are not strong enough to commit yourself wholeheartedly to virtue or to Evil. You preach the one, you disavow the other, even as you profit from it. How practical you are! And yet I could never sing the praises of your practicalities. Go on, accuse me of lyricism. Should any of your judges, court clerks, or prison directors ever stir a song in my soul, I promise you will be the first to know.

Your literature, *your* fine arts, *your* after-dinner entertainments all celebrate crime. All the talent of your poets glorifies the criminal you so loathe in the real world. And we, in turn, feel nothing but disdain for your poets and artists. Consider the impudence of an actor pantomiming a murder onstage, while every day children and men must suffer, if not death, then your contempt or your delightful forgiveness for their crimes. Criminals have to come to terms with their deeds. Out of what they have done, out of what you forbid them, they must fashion and lead a moral life on their own terms. In their minds—which can hardly be said to be theirs so long as you have the power to behead them—they are heroes as fine as those that thrill you in your books. Living on their own terms takes more talent than the greatest poets have—if they live.

And yet the heroes that fill your books, your tragedies, your poems, and your paintings continue to ornament your existence, even as you hold their unfortunate models in contempt. And how right you are! Because they would not deign to shake your hand.

Listeners who have seen the film *Sciuscià* may have been touched by the emotional tenderness shown between children brought together by the most delicate love. They admire adventures they would never dare to undertake, and of course they would never dream that such charming heroes actually exist. That they might steal actual money from actual parents. What we call theatrical talent has given us truly beautiful images, of course, but their more or less exact originals have truly suffered, truly bled, truly wept (less often), and have been refused the world's glories. The heroism you support is the tamest sort (incidentally, it is your artists, those charmers, who have never known it themselves, who tame it to your taste). The true body of heroism is unknown to you, as is the everyday suffering that it, just as much as you, endures. True grandeur slips past you. It is unknown to you. You prefer its shadow.

So if children are bold enough to say no to you, punish them. Be hard on them so they don't go easy on you! The problem is that you've been lax for too long. Your Tribunals, your Courts no longer observe the rites and ceremonies—not because you've substituted something crueler yet, cruelty in a suit jacket, but because sheer carelessness makes you show up in court in a tattered robe with a lining that may not even be silk, but is rayon or percaline. So enforce all the rules, especially the strictest ones. The criminal child no longer believes in your dignity, which amounts in his eyes to worn braid, ragged military stripes, moth-eaten furs. The graft, filth, and beggary of your courts disappoint him. He's right on the verge of granting you a modicum of grandeur, something he'd be able to wrest from a secret and solemn trial over which he would preside, and yet you persist in this mockery that, to him, is utterly infantile. Familiarity might

spur you to stroke his cheek and tilt up his chin for a minute, that is if you're not afraid of being accused of appalling inclinations rather than paternal indulgence.

But surely I'm joking, and surely this joke strikes you as heavy-handed. You know that you're saving these children. How fortunate, then, that the older rogues the children revere, the proud murderers, should be so alluring and the only competition you can put up are ridiculous prison guards in ill-fitting uniforms. Not one of your functionaries could help these children succeed in the adventures they've already embarked on. There is no allure like that of an outlaw. There is no act like the criminal act, which confronts an overwhelming moral and physical force.

And surely you can see the allure of Vacher, Weidmann, and Ange Soleil. "They had such potential, if only they had taken advantage of it," you say, and I take issue with those words. Only you can speak in language like that, the language of society, but if I were to examine you with rigor, you'd soon be at a loss for words. The men I've named took full advantage of all their potential and did it entirely on their own.

If sweet words can't win these children over, then all that's left is for your psychiatrists to cure them. And as to these, they have nothing but a few simple questions to ask that have already been asked a hundred times. Their mission may be to change children's moral conduct, but in the interest of what morality? The kind taught in textbooks? No man of science would seriously consider that. Is it a morality particular to each doctor? What would the basis be of their individual authority, then? There's no use posing these questions: they'll always skirt them. Psychiatrists are invoking ordinary morality, I know that perfectly well, as they label

a child a misfit. What can I say to that? As you are cunning, I will always confront you with my craftiness.

Today, as a poet who was once one of those children and who, by some mistake, has been allowed to go on-air, I want to say again how much tenderness I feel for these ruthless little thugs. I harbor no illusions. My words fall in emptiness and darkness. And yet, if only for my own sake, I must accuse the accusers one more time.

Translated by Jeffrey Zuckerman

'ADAME MIROIR

to Ginette Sénémaud

Description of a ballet
danced by Messrs
ROLAND PETIT, SERGE PERRAULT,
and SKOURATOFF
to a musical score by
DARIUS MILHAUD

SCENE: The set represents the interior of an extremely sumptuous palace; the hallways are covered with beveled mirrors. The place where the ballet is to be danced is a sort of crossroads where these very bright avenues meet. On the ceiling, rich, heavy chandeliers. No fabric on the walls, just gold, marble, glass.

THE TITLE: I want only to indicate this amusing fact: when I had just completed the play, I found the title "Madame Miroir," but the idea of such a ridiculous carnival prevented me from using it seriously. As a joke, I pronounced it for myself with a working-class accent, dragging out the "a's" and the final "oir," and, as in Belleville, I elided the initial "M." It seemed silly to write it that way, but I obtained a distortion of the word "madame" that gave "adam" in which a feminine past and possibility could also be read: "adam"

was, in a rather foggy mirror, the blurred, deformed image of an object having certain qualities.

THE MAIN CHARACTER: He is a sailor who has no past. His life begins with the choreography, which utterly contains it. He is young and handsome. He has curly hair. His muscles are hard and supple: in short, he is our idea of the ideal lover. He is dressed in the summer outfit of the sailors of the National Marine: white. Polished black shoes, with very supple soles. A rose is slipped by its stem into his leather belt.

THE DOMINO: It would be too easy to see Death in it. It is not death. Who, then? The author does not know. It is a domino of purple silk, gloved in black, whose essential accessory is a black crêpe fan.

THE CHOREOGRAPHY: The domino enters from a hallway on the right. One hand shading his eyes (the other holds the crêpe fan), he inspects the room, then turns his back and crosses the stage, examining each mirror *in which his Image does not appear*, going all the way back, to the left, where a hallway begins and he will disappear.

This character's movements must be slow and very supple. He gives the impression of being carried by a moving walkway. His gestures with the fan toward the mirrors are very familiar. He seems, sometimes, to be dusting a plinth with it, or a caryatid.

The domino having exited, light floods the scene, which remains empty for a few seconds.

The music plays a very light waltz, a sort of *java* [a popular dance—*Trans.*].

Where the domino exited there appears, cigarette butt in his lips, a sailor.

During the entire dance, the sailor's face will remain impassive (*he would be handsomer if he danced first with his eyes closed*) but when he appears (*going backward*), his gestures indicate fear. He retreats with tiny steps; and bumps against a mirror. He turns and sees his image. He runs to another mirror, where he again sees his image. (*A dancer, placed behind a mirror-shaped frame—veiled with organdy—has the role of the reflection, copying the sailor's poses in reverse.*)

With one mirror after the other, desperate, the sailor will collide, always bumping into his Image. Terrified, he dances alone, to an increasingly fast rhythm, until, exhausted, losing his cap, he falls to the ground, where he continues a sort of miserable crawling. Then he raises himself a bit and looks at one of the mirrors.

In this mirror (*the one at right, near the set*) the gestures of the Image do not seem to correspond exactly with the sailor's. The sailor gets worried. He creeps up to it, visibly mistrustful. While he is still crouching, the Image is already standing, at the edge of the mirror. The sailor stands up completely, and, with a sort of tender resignation, goes toward it. The Image then copies his last gestures. The sailor passes a hand over the mirror, as if to wipe away the condensation he has just made with his mouth. The Image performs the same gesture. Finally the sailor punches in the direction of the mirror, but instead of meeting glass, the hand strikes the

chin of the Image, whose head sways. The sailor brings both hands forward, the Image does the same, the sailor steps back, the Image steps back; the sailor again approaches, the Image approaches; the sailor steps back, but this time the Image advances and emerges from the mirror.

A dance begins (*first a pursuit*), the sailor and his Image, during which the mirrors stop reflecting.

THE PURSUIT: The Image, while dancing, tries to approach the sailor, who runs away, terrified. But at a certain point, the sailor, out of breath, is forced into an angle of the mirror (*fully visible to the audience*). Courageously, and a little intrigued, he faces his Image and walks toward it. In its turn, the Image flees. Finally, little by little, while turning their backs to each other, they touch, turn, and embrace. Kiss each other on the mouth. The Image takes the sailor's cigarette butt in his mouth.

THE DANCE: They dance. The same light waltz of the beginning, which they perform with little steps, like the sailors in dance halls: a very stylized waltz.

The two dancers try to evoke a lovers' chase. They take each other by the neck, then let go, dance cheek to cheek. They seldom let go of each other.

In the choreography she designed, Mlle. Janine Charrat made the Image lift the sailor (*from behind*) and let him down, then continue to dance. I will keep this idea, with this addition: lying on the floor, the sailor rolls over, crossing the whole stage from right to left. Standing in front of him,

watching him (*and facing the audience*), the Image moves with him, slowly, the four feet in harmony in these vertical and horizontal movements.

The rest of the dance must be extremely lustful. Erotic. The two dancers delicately perform the gestures familiar to sailors: raise their trousers with the flat of their hands, hook their thumbs into their leather belts, turning suddenly to present their profile, stretching, emphasizing their thigh and arm muscles, hands in their pockets to stretch the cloth on their fly, hang by their arms, etc.[1]

The dancers are on the point of uniting when, through the doorway where he had disappeared, the domino enters.

DEATH: As soon as he enters (*his walk still supple and slow*), the dancers become anxious. Nonchalantly, the domino advances. He seems to ignore them. He lingers (*fan in front of his face*) at the mirrors, but sure enough, he comes toward the defeated couple, who are separating. Finally the domino separates the sailor and his Image (*the domino's gestures as casual as possible*). The sailor and his Image dance finally with the domino. A frenzied waltz, more and more turbulent. The domino is carried in turn by the sailor and the Image, sometimes by both.

Finally the domino makes a decision and chooses the sailor. He pursues him for a bit, then stabs him with the closed fan. During the execution, the Image is leaning on an upright and observes the scene without showing any emotion. Finally the domino takes the prostrate sailor by his hair and pulls him into the wings, where they disappear.

*

For a few seconds, the Image dances alone, with a step that indicates solitude and panic. More precisely, it dances while moving backward.

THE METAMORPHOSIS: The domino returns. He pursues the Image, which escapes. Finally he traps it and dances with it, an extremely violent dance. The domino seems more and more menacing. He tries to make the Image enter one of the mirrors in the back. The Image resists and flees. Around the center of the set, the domino meets up with it. Not to the spectators, but to the Image alone, the domino, removing the fan, shows his face. The two dancers examine each other. By the agitation of their legs, their attitudes, we feel that they are tackling each other, are confronting each other. Finally the Image gives way. The domino takes its hand and, facing the audience, slips his long black glove onto the Image's hand (*choose a glove of silk jersey*). One hand gloved, the Image escapes and dances alone, but scarcely has it taken a few steps when it returns, without the domino having moved, to the domino's side. The domino takes the Image's other hand and slips the second glove onto it, then, with a double spinning movement, as the domino removes his robe, the Image clothes himself in it. (*The robe is just a long band of purple cloth.*) When the Image is dressed in the robe, it hides all but the head of the domino behind it. Finally, an arm (*clothed in white*) of what had been the domino offers, from behind the Image (*to the Image thus dressed in purple*), the fan. Then the character (*ex-domino*) reveals himself completely: it is the sailor from before. (*When the domino dragged him*

into the wings, a dresser quickly got him into the purple robe, so it is he who came on the stage to exchange costumes with the Image.)

The domino pursues the sailor. The sailor runs away. He tries to go back into a mirror, without ever being reflected in it. The mirrors resist. Finally he is joined by the domino, with whom he dances. The sailor again escapes. The domino throws himself into the pursuit. The sailor tries again one last mirror (*the one from which the Image had come*) and, slowly, backward, he penetrates the mirror.

The domino wants to follow him into it. Separated by the frame of the mirror, both dancers give in to a slight struggle. Finally, as if to take a better jump, the domino steps back. With the same gestures the sailor steps back, disappearing from the audience's eyes (*as a reflection withdraws from its subject, if the subject is removed*). The domino makes a leap that throws him against the mirror, but instead of meeting the sailor there, with a similar leap, it is his own reflection (*a purple domino*) that he strikes against. Surprised, he steps back. His reflection steps back. The music stops. The domino, then, with the same gestures he had at the beginning of the performance (*one hand shading his eyes*) examines the room, then the scene, the set, the palace. He sees the sailor's cap, the only sign of what must have happened. He leans down and picks it up, then continues his path to the back of the stage, but now each of the mirrors reflects the Image of a similar Image.

Finally, the backdrop being a prop in the form of a double mirror, without anyone seeming to move it, this door opens as the domino approaches it, following his rhythm. His movement is as described above, and, after he crosses the doorsill, since the floor slopes down, his body disappears like a ship's mast over the horizon. The curtain falls.

A FEW DETAILS OF EXECUTION: The dancers must dance keeping close to the ground. They never leap. Their gestures are exaggeratedly heavy.

When the Image comes out of the mirror, it does not step over the frame, but a sloping surface must allow it to *descend* from the mirror without raising its feet.

The three dancers work for a long time to achieve a sort of similarity of gestures.

This entire melodrama must give the impression of a game. To that end, the dancers charge their gestures with outré intentions: obscene, villainous, criminal.

No irony. It is a ballet for the Grand-Guignol. The domino will be a band of cloth that is wrapped like a sari. He wears shoes with rather high heels. Even when he dances and kills the sailor, he must give the impression of being asleep.

THE MUSIC: A series of accordion waltzes or cleverly stylized popular *java*s in which the accordion and harmonica are dominant. Music that is called "nostalgic."

This ballet was danced by M. Roland Petit to choreography by Mlle. Charrat.

The idea came to me at the Montmartre fair, in front of a sort of Palace of Mirrors in which the onlookers seemed imprisoned, bumped into their own image, and seemed incapable of finding the exit. I remembered a similar scene of which I had been the troubled witness, in Anvers, long ago. Superimposing in my mind the two episodes moved me, and, in a few minutes, I worked out the ballet I have just described.

Translated by Charlotte Mandell

LETTER TO LEONOR FINI

A "PESTILENTIAL" smell: this can be recognized, by a wide-open nostril, as being composed of a thousand scents, interwoven, yet distinct according to each level and layer, in which you might find ferns, mud, the corpses of pink flamingos, salamanders, marsh reeds, a population of heavy scents, at once salubrious and harmful.

If they had to arrange themselves and make themselves visible, these scents would choose the hesitant, though precisely distinct forms of your drawings and paintings (this open nostril, you have painted it, and on it, on its cartilages, you have lingered for a long time, neglecting every other part of the face, above all you have taken note of its quivering. You wanted it to breathe in your—breathable—work and the exquisite and poisonous smell of your work).

If I fasten on the olfactory sense to speak about them, it is not because your drawings *immediately* evoke a smell (the way a certain music evokes a way of walking, for instance), but their complexity and their architecture seem to me comparable to the complex architecture of swamp odors.

Your work hesitates between vegetable and animal— mosses, lichens, as well as the most ancient animal representations following the most ancient method: the Fable.

But, aside from the fact that it is in the humid undergrowth that we might discover your giant orchids and your dwarf

sphinxes being born—and, with difficulty, freed—from a fog itself born from an antediluvian nostril—where they proliferate and breed a dazzling universe—this smell seems to contain a smell of carnal humus and elemental plants.

Your person, Mademoiselle, which seems thus not to be painted, but depicted (de-picted), is almost obscenely akin to these two elements, vegetable and animal. The very sex of your young heroes rests, calm, in a tranquil moss. You are the marriage of plant and animal.

If your flora are *copied*, however, your fauna are invented. In fact, your paintings represent actual flowers and imaginary animals. But what dominates above all—the major scent that I have recognized—is that of death. The choice of colors, the anxiety of scenes, the meeting of a shell with a mirror, the folds of cloth, your masks—everything, in your work, bears witness to an intimate, macabre theater. Your paintings are sprinkled with ash. Like lichen on the trunk of a fallen tree, a skeleton's long hair continues to grow. Everything smells of death, the high boredom of an afterlife or an incalculable age.

They talk, with justice, about your technique: your perfect drawing is the sign of a refined civilization nostalgic for a life, not underground, but elemental, the one we can guess at in the depths of the oldest forests, the decomposition of which produces will-o'-the-wisps, those nymphs scarcely liberated from tree bark. It is, no doubt, in order to dominate this luxuriant, burgeoning, invading universe that you compel yourself to an exact precision about the color and shape of your objects. That is the only thing that allows you to confine the flood of seaweed, sirens, reptiles, that, tugging you by the hem of your dress, try to drown you. The technique of your drawing is thus supremely prudent.

Madame, I also see in it some kind of subtle science, and a sort of cunning—to give us only a polished image, a reflection, of your private adventure. But these characters—sphinxes, griffons, chimeras—who were once the supporters of a coat of arms or a wall hanging, now stop being decorative. They have devoured the humans they used to serve, who had tamed them, and in their turn, they sprawl in the sheets, chew rare herbs.

The era you live in is the Renaissance: I mean that you illustrate a theme that, historically, is called the Italian Renaissance. The splendor of this era is the same as that of your work, voluptuous and sprinkled with arsenic. Your ladies stretched out in the boudoir, their elegant boys are imprisoned, are stricken with a plague that comes from the highest Antiquity.

But a study has an aim: to reduce the work of the artist to a simple expression, or, as the philosophers say conceptually, a lived experience; to give or extricate the meaning of the work, to reestablish its relationships with the world and its time.

If you so firmly hold the bridle of the fabulous and shapeless animal that is erupting in your work and perhaps in your person, it seems to me, Leonor, that you very much fear letting yourself be carried away by savagery. You go to the masked ball masked in a cat's muzzle, but dressed like a Roman cardinal—you keep to appearances, lest you get lost in the sphinx's rump, and sprout her wings and claws. Wise prudence: you seem to me on the edge of metamorphosis. But if you tolerate any advice at all, I will advise you to stay not so long in the human world, in order to return to those dreams in which you call your sisters, the ivy-imprisoned nymphs. Do not think, Leonor, that I am joking: Stop the game of appearances: appear.

This aquatic, feverish world, stagnating in a jar, I feel it rush up to the luminous surface where it will be annihilated, I mean up into the intelligence that faces have. I will explain, but I needed that confused sentence: the whole mystery of a vegetable-animal conspiracy seeks to be resolved in a purified countenance, in a face.

Everything that seems to lurk at your heroes' feet, everything that tries to adorn them and comes near them, brushes against them, soils them, all that stagnates or bursts in the dark, climbs slowly up and becomes purer and purer in order, finally, to explode softly in a look or a smile. So I foresee an era when your faces will be rich, secretly fed by all those dramas that must remain invisible, swallowed up, eaten by your heroes. One day, the handsomest of your portraits, having devoured it, will dream your work, that theatrical part of your work: then you will be a great classical painter.

Explaining your future method to you, my impertinence suddenly becomes apparent to me. But I am a poet who knows that the work of art must resolve the drama, not display it. These rags, these holly trees that destroy them, these animals, these flowers, these sumptuous diseases, these personified passions—I want them to be legible only in the break or the curve of lines of the clearest face. Your science of drawing and color is too great, and too rich, and multiplies the drama that preoccupies you, for your portraits not to be profoundly aware of it. Of all your phantasmagorias, only an upheaval in profundity will remain in the features, resembling something like a trembling shadow over your work. I know that your great honesty will make you continue not by the easiest way, but by the most dangerous.

Forgive me, Madame, I am hastening toward conclusions

that displease you perhaps, but I want you to be worthy of being presented in that tiny room in the Louvre where there hang two portraits by Dürer, two by Cranach, and two by Holbein. I wish you, Madame, immense difficulties.

I have noticed, too, the silence of your canvases, the silence they establish, the silence of the links they represent, finally, the silence of your heroes. A Japanese fish makes me think of it. Like one, you seem to move in an element so sensitive that any shock, if it were not covered with felt, would take on the proportions of thunder. Like your pieces of cloth, the transparent fins of the fish I am looking at—oh, but you evoke the entire subterranean world, seaweed and pebbles!— have the same appearance as the feigned sleep of a cat. They are on the lookout. We suspect them. That at least is what I feel when faced with them.

I wonder to what this silence corresponds when I compare it to the chattering loquacity of the Italian artist. In your person everything moves: the eye, the breast, the foot, and, excuse me, the tongue. But you paint a mute world. Silence, crime, incest, poison, death, venom, smells, church, cenotaph, reptile, sea, roots, anxiety—I jot down, haphazardly, the elements of a theater that is pursued—or prepared for?— even in your daily life, but then, in a merely verbal way. Where does the actual performance take place, then? I pose an indiscreet question.

As to these slaves, these shaved convicts, where do they come from? What penal colonies do you pull them from, or rather, where do you cast them? For I cannot believe that they serve only as decorations for your games. They are not pretext, but end. Too much pathos is expressed by gestures that are paradoxically clear and empty (where, among the

slaves in one picture, you have placed the most angelic azure); by their mouths, open—if they are breathing out—or closed if they persist in their scorn; by their cropped skulls.

At the final boundary of your work, then, you are preoccupied with the condemned world where silence has the power of aesthetic necessity. Maybe that is what will let you rejoin the most earthly, most "human," most carnal unhappiness. If, till these final days, you have given a solemn life to the most elegant wax candles, perhaps you will confer unhappiness and life on the lowly peat fire.

On the surface of your world swim all sorts of chignons that—allow me this coarseness—seem to me as much vomited as painted. I do not know how to speak accurately of hair and the effect it has on us, except that we recognize that it sickens us at the same time as it charms us. But you use hair to both these ends, simultaneously. We want to caress these curls, but also to get rid of them with disgust. Cut—and curiously these days, in your most recent paintings—the most beautiful, purest, most luminous heads appear, not only in their brilliant baldness, but also—despite sadness—with brighter eyes and fresher smiles or pouts. I have the tactlessness to see in them the quest to strip bare the physical, the social, in favor of an inner richness.

No doubt, other bald people, sumptuously dressed, stroll about in your old dreams, but I want to see them like the signs of a scattered, but violent asceticism. Convicts, the downtrodden, hard-luck men wandered about in your world of cloth and flowers: you recognized them, separated from the rest, and now you pay special attention to them.

We are free to interpret as we like, to use, and make them serve us, these signs that we have just chosen: for me, these heads of hair were the signs of the earthly world; these shaved

skulls were signs of the most terrible curse and signs of inner realms where those still adorned with physical accoutrements no longer have any right to look, so I choose for you this more difficult procedure: the song of the living dead.

The idea of convict and punishment was already contained—implicitly understood—in those scenes of draperies powdered with arsenic, in that world of poisoners and infanticides; today, it finally manifests with an ironic precision. It is this idea that we want to exploit. And surely, if it denies us the possibilities of a more human, more social attractiveness, it may still let us discover the riches of the curse.

But I was speaking of dream. Your work seems to belong to it, but not entirely. It has to do, rather, it seems to me, with vague and vaguely directed daydream, now toward the vegetal and now toward more refined forms of culture. It was easy enough for you to take these daydreams as a starting point and then embellish them, to invent forms and imagine scenes, but now, starting from these shaved heads, it seems to me that your awareness will become greater and your attention more thoughtful. It is not only to form that you should bring the particular logic of the artist; it is in you yourself that you must seek out this unhappiness that we recognize in your new heroes, since you uncrowned them.

It is perhaps only the despair that your heroes express that will allow you to invent a profusion of new forms, in order, precisely, to retransmit it to us, transformed—and, I dare assert—in the form of a celebration. That the disillusioned smile—and it alone—the sorrowful look, the pout, the scar, will be a pretext no longer for a sad, fixed drama, which is waiting for who knows what speech to go on, but for an actual gala, not only of shadows and forms, but also of joy: that is the miracle of poetry.

Of course, you will find that I quickly picked out what is closest to me, and that it is first my own fault that I exalt. But would I be so passionate about a work if I had not discovered in it, from its very formation, not what I am heading toward already—and that will belong only to me—but those same desperate elements scattered throughout funereal ceremonies?

In short, till now, what have you been doing? On canvases, sometimes the world of your daydreams, sometimes that of your dreams, you have offered us a representation of them. If such an occupation allowed you to perfect your artistic gifts, it is only as you bring yourself up to date about a desperate world that we will understand your poetry. There exists a moral realm. It is absolutely the only one where it matters that the artist discover it by means of form. But it is the most perilous and noblest moral domain that interests us—as to its nobility, no preexistent law instructs us, we must invent it. And it is our entire life that we must conform—make conform—to this invention. To say it quickly, it is toward sanctity that, through your art, we want to see you move.

These convicts' heads—or what evokes them in your work—are themselves charged with a darkness as thick as the one that floats in your paintings and confuses the numerous elements in them, but it is not the same. Here is where we can speak of the darkness of the heart, when earlier you had mostly exploited the world's night.

"One day the most handsome portraits will dream your work," I wrote earlier. I think it's done. Those shaved heads have become iridescent with the scenes they glimpse and that your hands have fixed in a solemn eternity. The troublemakers of your dramas, you have made them climb back up

out of your penal colonies—where you had cast them—in order not to perish there, but to complete the drama. For it is they, isn't it, who are responsible for these sumptuous orgies? The expression "a cruel goodness" seems to me to be apt to designate this period of yours. By welcoming it and coming to terms with it, you do not relinquish your riches from before. These adhere all too much to you, they are all too much your prehistory, and your convicts—or executioners—your indestructible ambiguity already makes them float, tremble, vacillate. Truly, they are not guilty of mere earthly crimes, they carry in them responsibility for your most intimate dismemberment. Not one child in your world. We look in vain for an innocent gaze; all are charged with a knowledge that is undoubtedly only the science and anxiety of the artist, for whom original purity does not exist. It is earned. And already your slaves have the sadness not of the evil they are going to perform—or, like your previous characters, that nostalgia for an evil that they do not have the strength to attempt—but that light and profound melancholy of men who have nothing left to do but organize, like a celebration, a life that is placed beyond despair.

I was able to take even more joy speaking about these magnificent images, each of which could be the projection of what I would have liked to become.

What do you want? What are you looking for? Flowers, animals, you already knew how to show them *outside* their uses as flower and animal, that is to say, as innocence. They all bear the mark of a voluntary crime. Fortunately. Thanks to that—to that charm over us—you will no doubt avoid the penal colony to which you seemed to me to be destined.

Translated by Charlotte Mandell

JEAN COCTEAU

GREEK [*Grec*]! The dry elegance of this word, its brevity, its rupture even, a little abrupt, are the qualities that can be readily applied to Jean Cocteau. The word is already a fastidious work of cutting: thus it designates the poet freed, cut loose from a substance whose chips he has made vanish. The poet—or his work, but even so, it is still he—remains a curious fragment, brief, hard, blazing, comically incomplete—like the word "Greek"—and one that contains the virtues that I want to enumerate. Luminosity above all. An illumination, above all uniform and cruel, showing precisely the details of a landscape apparently without mystery: that is Hellenic Classicism. The intelligence of the poet, in fact, illumines his work with such a white, raw light that it seems cold. This work is elegantly disordered, but each of its shafts or plinths was rigorously worked over, only, it seems, to be broken and left there. Today, beautiful foreigners visit it. It bathes in a very pure, very blue atmosphere.

It is not just playfulness that makes us, in speaking of Jean Cocteau, develop a metaphor. The word "Greek" was chosen by him, and he often sought to illustrate or refer to Greece as a whole. That is because he knows the darkest, most subterranean, wildest, almost insane aspects of what it signifies. From *Opéra* to *Renaud et Armide*, we guess these columns and broken temples to be the visible form of a pain

and despair that chose—not to express themselves—but to hide themselves, by fertilizing it, beneath a gracious appearance, one that is a little mundane, since it seems understood that the noble collapse of Hellas belongs to a frivolous world. That is the tragedy of the poet. A deep human humus, almost foul-smelling, exhales whiffs of heat that sometimes make us red with shame. A sentence, a verse, a drawing of a very pure, almost innocent line in the interstices between words, at the point of intersection, emit like smoke a heavy, almost fetid air, revealing an intense subterranean life.

That is how Jean Cocteau's work seems to us, like a light, aerial, stormy civilization hanging from the heavy heart of our own. The very person of the poet adds to it, thin, knotted, silvery as olive trees.

But to have borrowed such forms was dangerous, for the least-developed minds came up with the notion of pastiche; while others even worse, gravely pondered this elegance alone and not what summoned it. So today, here, we want to draw your attention not to the way in which the poet hides himself, but to what it is he seeks to hide. Poems, essays, novels, theater—the entire body of work cracks, and lets anguish be discovered in the fissures. A vastly complex and sorrowful heart wants both to hide and to blossom. Is it a profound intelligence that makes this work infinitely sad? It trembles. We know that our images aren't very precise, but when expressions like "heavy chagrin," "profound despair," "wounded heart" are uttered, what remains to be said? As soon as we see a man's pained face—sternly in command of his pain, managing to transform it harmoniously—how can one speak with precision without a wounding pedantry? Jean Cocteau? He is a very great poet, linked to other poets by the brotherhood of the brow, and to men by the heart. We again insist

on that, for it seems that a deplorable misunderstanding has developed about it. The grace of his style had to become the prey of what the world thinks of as the basest thing: the elite.

Which wanted to monopolize, make its own, this elegant form, neglecting the delicate bitter almond it contains. This time, though, we violently refuse this compromise and come to claim our rights over a poet who is not light, but serious. We deny Jean Cocteau the stupid title of "enchanter": we declare him "enchanted." He does not charm: he is "charmed." He is not a witch, he is "bewitched." And these words do not serve just to counter the base frivolity of a certain world: I claim that they better express the true drama of the poet.

Others besides me, cleverer, more learned, will speak to you of Jean Cocteau's place in literature, of his influence on Letters and on several generations, of his style and of the transparency of his poetry; as for me, I am concerned only with his heart, cultivated according to a rigorous morality and producing that rare plant: goodness. You understand: I am speaking of the quality that is more intelligence than sensibility, that is extreme comprehension. It was no doubt pursued and attained at the same time as the perfection of style that testifies to it. I call on you to try to find, word by word, line after line, the severe—parallel—progression of the purity of the writing and of moral honesty. Jean Cocteau never gives us shameless lessons on morality—if he had to advise us, perhaps it would be with a malicious smile, the opposite of morality, but his sentence is constructed with such a respect for verbal substance that this attitude, which is presence of mind, remains every time. It is then the rarely faltering rigor of a way of life that I invite you to discern in this style. Lightness, grace, elegance are qualities that refuse

laziness and weakness, but what would they be if they were not applied to the hardest materials? But unlike the workman who, out of preference, chooses marble, the poet, by the choice of his method and his words, creates marble. Earlier we spoke of Greece. You will understand now: it was a matter of this new marble: the moral idea we shape from it.

Translated by Charlotte Mandell

FRAGMENTS...

The pages that follow are not extracts of a poem: they ought to lead to one. This is a still-distant approach to one, since it is only one of several drafts of a text that will be the slow, measured progress toward the poem, justification of this text as the text will be of my life.

—J. G.

FRAGMENTS OF A DISCOURSE

THE MOROSE eyelid—where the chimera was broken, you were keeping watch.[1] But, from my darkness miraculously won, for my sheets, now you are coming to lick me from outside, still naive, still hesitant: the kid and the young cavalier, the girl and the sun, the rose and the boy, the moon and death—at every instant another metamorphosis—death and this book. To whom if not you, to talk about you in order to establish—all the way to mutual downfall, echoes always more muted—a useless dialogue? About your person: here are the worst features. Take refuge in the horror of this text first, then in our confusion, then in a solitary region, beyond reach, in Legend, if you dare. Or, find the route of my humors: blood, tears, sperm, for my most secret orgasm, curl up in it and in this cyst begin again your one-eyed vigil.

To discover what? You are rotting. To come back? How, unless I swallow you?

Sign, unalterable face, whose absolute content is death! To be surrounded by it, a perfection that, from within, the occasion seeks. Each of your steps—your long, nervous strides—could bear your name. A subtle ankylosis distinguishes each one from a walk that carries you to the coffin. Shameless and handsome, spitting your gobs of spit into the street, by dint of the beauty and shamelessness that well up from your youth and your cough, be the provocation that walks and vanishes. Your step! Death marks it. And it plumbs your eyes. Apart from yours, what vices can be magnificently illustrated, brought to incandescence? Shame—whore, thief, consumptive—by force of shame comes respect. For you and for your sole use, write your legend. Clever at polishing yourself, your heart no longer beating, in no matter what posture death defines you. Monumental, complete in all movements, you are surrounded by death. Sliced apart, each of your steps can be put on display in a shop window. You, still among us, traveling our streets, may you be named, insolent and victorious strumpet, who are going, by the power of your nerve alone and your beauty, to take refuge mechanically in the sky of History.

When the idea is extinguished, the word sparkles with all its abandoned possibilities. It is empty. The idea is finished. Today—in this place—useless for any future act, the idea is fixed, sterile. Wives and daughters of kings, Phaedra, Antigone, dead, then legendary, finally a gleaming collection of

letters—and you—have won absolute prestige: death. Useful for saying nothing, now you are in the timeless. Was that a victory? Underwear, sweat, shoes, tears—wherever you blow your nose—will not prevent the void from isolating you. If these were mythological tales, the analogy of yours would have dehumanized that melancholy lout crouching on his bed. Clean out your nostrils, look at the snot with amazement, flick it or eat it, your gesture will not be linked to what follows. But what, then, is the quality of this child I am killing, this delicious whore, whose everyday activities have the force and gravity of old myths?

They—or you yourself—do not forgive your beauty. They—and you yourself—would only burst out laughing before the inextricable curses that overwhelm you. You will soon be nothing but the memory of your beauty. The song of it will survive, then the song of this poem that you desert, and further on, perhaps, "the idea of infinite misery." Work. Brilliantly manifest what the world has already condemned in you, not the stars. Give the whore you are the coldest semblance. Taken from your shame, the wildest earthly fineries will adorn your person. But who, what demon—or you—is so bent on demolishing you? Destitution, tuberculosis, prostitution, that hairy spot on your thigh!—and soon your blindness, are your undoing. You, whose beauty is famous in Rome, who persist in making yourself and unmaking yourself by coughing up a fate so carefully planned that here you are, cut down to suburban scale, one of the inimitable princesses of the great Greek dynasties?

*

From what is the fabled camellia protecting you? Steam is worth nothing to your delicate, flowery bronchial tubes. Feet bare on the tiles, dressed in a terrycloth towel, in the condensation that, along with shame, pushes you back and cuts you off, you could have offered your golden rump. Rump presented to old men's dicks. Your inner collapse held you back at the door. What a dream for your pride, you, the most desired one—without knowing the ones in Rome, I watch you in the Turkish baths where you thought of prostituting yourself—waited for, offered, conqueror, infernal among those oily and wounding bodies, traveling through silence and illuminating it by: your teeth, your eyes, your cynicism, that mass of white, sweaty steam.

For them—tuberculosis and death—here is my remedy: you are a whore. The *word* is not a title, it tells your profession. Be a sublime whore. You recite—as the poetic language entirely within you turns toward death where you are lazily burying yourself—with a high, expressionless voice an erased text. What will die when you die will be not a man, but a herald, bearing depleted coats of arms.

Nocturnal! These unusable words that want to disembody you, then transform you into a vague, uncertain, yet real product of language, they are not brought in just by whim: you are nocturnal,[2] sick, and false; never wondering at daylight, the rational, and your eye is astonished. Lucid, the beginning of this letter placed you in a vaporous element that your material substance cuts and shapes, but in which you participate, in which dreamily you take refuge. Never

next to or facing the other, you enter him if you aren't already wrapped round him. He inhales you and vomits, or you suck him in and in your white belly, swallowed, he sleeps in a ball.

Certain emblematic characteristics will illustrate you: your illness. You are dying from your chest. Rottenness lives in this place, which without it would have been deserted. Here, to define you, are some insidious suggestions: a cough will carry you off, have one foot in the grave, vomit your lungs, spit oysters . . . terrific! This masterpiece of grace, this david, this perseus who walk, who move their heads, who climb a staircase, who button up their flies, who soap themselves and paint themselves, they were rotting. The exceptional light of the translucent cartilage of your nose shows that this admirable appearance is decomposing. Stopping your skin from being proud and vain, sickness forces it to meditation, to sadness, to grief. Tuberculosis makes you live. It is a giant bacillus that makes you distinctive with . . .

. . . hide, moss, lichen, traces of the monster! Covered with a too-smooth fur that does not belong to your body, but to the animal of which it is the last visible trace that you preserve, a stain almost purple, plated on your thigh, gives your beauty the unique seal. It makes your perfection shameful, but especially when your hand by mistake rests on it—or your lovers' gaze—it hurls you into a solitary Antiquity, shadowy and mocking. You, a smile a challenge and anxiety then on your mouth: red alert!

THE PRETEXT

The thought—not the summons—but the thought of suicide, appeared to me clearly around my fortieth year, brought, it seems to me, by the boredom of living, by an inner void that nothing, except an absolute decline, seemed able to abolish. Still, no vertigo, no dramatic or violent impulse propelled me toward death. I calmly considered the idea, with a little horror, nauseous potion, and nothing more. At the time, after some wretched affairs undergone and then transformed into songs from which I tried to extract a particular morality,[3] I no longer had the vigor (though I felt the innermost urgency) to undertake a work that came not from fact, but from clear reason, a calculated work that came paradoxically from number before having come from the word, from the word before the deed, undoing itself as it unfolded. This weird demand was then illustrated by this formula: to sculpt a stone into the form of a stone. For reasons I will give, hardly interested in the world's fate, having (or believing I had) accomplished my own, by my inner void condemned to silence—sculpting a stone in the form of a stone the same as being silent—logically and naturally I contemplated suicide. What exists, existing, the powers of poetry, seemed vain to me: I had to disappear. Or exhaust myself in a long moment—until my natural death—in contemplation of the one I had become. Or mask my boredom beneath vanities.

Homosexuality is not a given that I could get used to. Beside the fact that no tradition comes to the aid of the pederast, or bequeaths him a system of references—except by omissions—or teaches him a moral convention having to do with homosexuality alone, this very nature, acquired

or given, is experienced as a topic of guilt. It isolates me, cuts me off both from the rest of the world and from every pederast. We hate each other, within ourselves and within each of us. We destroy each other. Our relationships broken, inversion is lived solitarily. Language, that support endlessly reborn from a link between men—pederasts change it, parody it, dissolve it. Among themselves, freed from the severe social gaze, these queens recognize each other in the shame that they dress in faded finery. Reality[4] loses ground and lets a tragic insecurity appear.

To die on the field of honor, your carnivals, Queers, have this extravagant allure: bugles, flags, and to croak riddled with shrapnel to save France. This long, declamatory suicide will never end, except death in the form of heroism, in order to return from that distant exile where woman is absent. But wars are rare. So, patiently, you will wait for a deed you can perform to restore you to the Fable: abstract universe, where you will be a symbol. Truly, in the massacre of Chaeronea [the massacre of the "Sacred Band" of young Theban warriors during Philip of Macedon's defeat of Athens—*Trans*.], could we see anything but an enormous suicide? Still, when the wish to quit life through the sign becomes urgent, patiently observe in yourselves what long, tragic cries call you. But—feathers, petticoats, eyelashes fluttering, fans—it is a funereal, but frivolous carnival that burdens you. Where can you take those rigors that order the themes, overcome them, write the poem? Where, finally, are the great tragic themes? Queers, you are made of pieces. Your gestures are broken. Do you expect a bullet finally to freeze you on the

field of honor, so that you might be allowed, monstrously, to live through the metamorphosis for a few seconds?

In the heart of a living and continuous system that contains us, that stumbles on reality and changes it, no pederast can be intelligent. Like their voice on certain words, their reasoning drifts or breaks. Now the notion of rupture appears.

Pederasty comprises its own erotic system, its sensibility, its passions, its love, its ceremonial, its rites, its weddings, its mourning rituals, its songs: a civilization, but one that, instead of connecting, isolates, and that is lived solitarily in each of us. Finally, it is defunct. Accumulating, as it develops, gestures and considerations perverted by notions of rupture, of limits, of discontinuity, it constructs only apparent tombs. So I am going to try to isolate one of those dead civilizations from its living and continuous context. I will present it as purified as possible from all life.[5] Of this Egypt that is sinking little by little into the sand, futile and grave, they will discover only a few fragments of tomb, a fragment of inscription.

But first let us kill the adolescent in us, then stifle the other. His aim, outside of the criminal, crime certainly causes a death, in the soul of its perpetrator it works its ravages, this act, alas, scarcely finished, fades away: it only passed by. When the victim is cold, does the crime cease, or live on in rage, remorse, scenes, eternal, glimmering regrets? Then let a sterile act revive an appearance, eternally cold and sterile. May the crime never stop being accomplished. His tale is not enough. The criminal turns within. He proceeds to his own expiatory murder of himself. Starting from the crime—rupture—he develops a rigorous logic and discovers

laws, rules, and numbers that lead him to the poem—
the final sterile act that does not end by being performed.
If our first crime was to refuse life and banish Woman,
I will track down in myself the child of whom I will
speak—whom I sing, dissect, and disembody—I will
finish him off until the poem appears. Not so this fairy
will hate me, but so that my destination, after this first
crime, can be to perpetuate him according to rule and
measure.

A civilization with its characteristics would have its own
morality, if we call "morality" the lucid, voluntary attempt
to coordinate, then harmonize the scattered elements in the
individual for a goal that transcends him. But mine could
not be ordinary morality. Pederasty is evil. To come to terms
with it completely, inversion comprises, logically, the idea of
sterility. The homosexual refuses the woman who, ironically,
takes revenge by reappearing in him in order to put him in
a risky position. They call us "effeminate." Banished, seques-
tered, deceived, Woman, in our gestures and intonations,
seeks to be seen in daylight, and finds it: our body, holed
from the start, becomes unreal. It is no longer in its place in
the universe of the couple. The condemnation directed at
thieves and murderers is remissible, ours is not. They are
guilty by accident, our sin is original. We will pay dearly for
the stupid pride that makes us forget that we come from a
placenta. For what damns us—and damns all passion—is
less our unfertile loves than the sterile principle that fertilizes
our acts, the least of our deeds, with nothingness. And so?
Is it possible that my erotic frenzies constantly turned on
myself or on the granite my lovers are, that these frenzies
whose aim is my pleasure alone, accompany an order, a

morality, a logic linked to an erotics leading to Love? I have hunted woman. Given this childlike and sulky attitude, I will pursue her with a coherent rigor. True, I refuse my tenderness to half the world, I refuse to follow the order of the world, innocently and clumsily I clear off: it will be solitude. Sterility will rise up and be constituted as action.

The end will be luxurious, the means wretched. With meticulous care in which no fragment of a second is spared, my mortal progress is carried on. This care—it is really our uninterrupted impatience with regard to the fierce lover whom his tuberculosis, helped by us, illuminates and kills. Everything will end with the dissolution of the one whom, unable to reach in his person, I will contain. Glory: to erect a tomb that will never exist, will never have existed, will enclose nothing. But to build it, and above all, secretly, and with great ceremony,[6] with a fierce hand to discover or reveal its pretext: a corpse.

The visible enterprise of every man is composed of acts that break the law. From any life, what remains? Its poem. At most a sign: the name become exemplary. In turn, the name and the example vanish, and "an idea of infinite misery" remains. Beyond its consoling and definitive harmony, this formula has this power: it completes me in what composes me. Thus explored by two bare feet that raise a wretched dust, if my glory were not this dust, this misery, these bloody feet, then what, what gold?

This singular dying man I am keeping alive—about whom I am speaking to you—watches over the caverns pitting his lungs. Caverns—that a pneumothorax is

supposed to reduce—this word, with caution and silence leads me into grottos that conceal—treasure, dragon, apparitions of Mary, chimera, or lily—nothing. Except my terror in discovering there, natural guest of these cavities, my invalid busily dying tenderly.

Each act wants to be sumptuous. Its idea is loaded with pomp. The essence of the means is misery. Each minute glory completing each act full of misery, the self of words is a death. Wanting to be written, memorable, each act is historic—whether it wants to be inscribed in one single, short memory or in many. The deed that breaks the law has a power of writing.

It is a profound misery, so dense that it sparkles, is actualized, and is called here beauty or glory. That is the idea of infinite misery that I want to rediscover. If it is the very essence of glory, may this idea alone remain attached to my name. May my name disappear, and may there remain this single idea of infinite misery.

If it is true that each work is pursued and completed according to a rigor that refers to nothing but a constant fidelity in its relationships, thus in a life that, comparable to the work of art, is rupture and end in itself, all morality is only coherent order referring to nothing but a constant fidelity in the relationship of actions between themselves. Queens, our morality was an aesthetics.

From every one of us, Woman—and whatever love, continuity, hope her approach contains—will be absent.[7] I will be dry, mineral, abstract. Let's have a shot at it. So, during this dying existence, in which constantly appearing death countered constantly by thought then by the action born

from thought, during this existence paradoxically composed of sterile acts, if between them and the funereal principle that orders them I realize a strict correlation, perhaps, by these relationships alone I will realize a logic having its own laws and meaning: as rigorous as the logic in which the principle of love is contained. If I succeed, I will have won a curious virility. Alone, like an extinct civilization, my meaning *will speak* as equal to equal with the world where we are in the world, with that universe that perpetuates itself. Alone already, solitary, I consider it from the bottom of a well, refracted. It is no longer made for me. What fatal event, clumsy and cruel, from my childhood on—my tender child-hood—made me thus steer clear of life? Incapable of an act that would have freed me from it, I chose this symbolic, but imperfect death. I should have died. Since then, I keep my-self in suspense between death and life. That is the meaning of our ambiguity: we couldn't decide in favor of either one of them.

So I had undertaken to suffer pederasty, that is to say, guilt in its complete demand, by treating it with rigor, trying to discover its elements and its consequences, all of them come from evil, antisocial obsessions. From the pederastic given radiated a complex, imaginary crime—betrayal—that I tried to live, to actualize in myself with the greatest sever-ity, in short, to transmute into a moral attitude, although I was living in a universe that imposed laws on me—from which laws I was borrowing a simulated security, to control myself—drawn from a complex resulting from the idea of continuity. Drawn to that traditional totality that condemned me and from which I had proudly excluded myself, my at-titude was false and painful (inside this living organism, my pride had not magnificently isolated me so I could be the

chief, or the only one: it is the organism that exiled me. Pride changed the exile into voluntary refusal, but the luminous, endlessly desired solitude of the artist is the opposite of the dismal and arrogant reclusion of pederasts).

Strange mistake: a young lower-class boy had a face in which I thought I read the adventures we attribute to criminals. His beauty hooked me. I linked up to him, hoping to relive in him a passion outside the law. But he was solar, in harmony with the order of the world. When I saw this, it was too late, I loved him. Helping him to realize himself in himself and not in me,[8] little by little, subtly, the order of the world was to change my morality. Still, helping this child in his effort to live in the world harmoniously, I did not abandon the idea of a satanic morality that, no longer lived according to a passionate cynicism, became an artificial, antique notion. Lucid again, I knew myself in confusion and comfort. Resolving, through a calm insolence, through the calm assertion of myself, the social scandal provoked by pederasty, I thought I was free of it with regard to the world and to myself. I was weary, even though the anxiety of eternity rose up, tormenting, an anxiety incapable of being translated in my case through the sequence of generations, or by the idea of continuity filling my acts, an anxiety I expressed by my search for a rhythm—or a law within my system alone—or a Golden Section, eternal, that is to say, capable of engendering, connecting, and completing the finished poem, perfect obvious sign, untouchable and final in this human affair, my own. I was in that state. In April 1952, in X . . . I met a twenty-year-old hoodlum. I fell in love with him. This country was then, and no doubt still is, an immense brothel where the pederasts of the whole world rented for an hour, for the night, or for the time of a journey,

a boy or a man. Mine seemed at once delicate and precious. Neither his strangeness nor his beauty was obvious to me at first. His features seemed as if powdered with talc. At our second meeting, through a provocative sort of game on my side, by way of challenge, I expressed my disgust for his profession. Irritated, he offered to leave me. I accepted. He wanted to leave, stayed, left: I was in love. Magnetized, he led me on by the effect of a force whose nature I can only poorly define if it is in him, but if this appearance of power is only the appearance of my desire trussed, chewed, swallowed, shit out, I don't understand it any better, at least the poem doesn't help me to. I persisted in my desire for him. He was terrible, the lout I wanted to turn into an ornament with a hard-on, with open ass, and at the same time a friend. He fought against me.

Let them bring me a corpse. Tuberculosis is a disease of slow progression. But certain. The hero responsible for this infernal debauchery seems not to contain it, but to bathe in it, in a subtle element that reduces him to the point of annihilation. It is not so that he'll live and survive that I help my lover; it is so that he croaks. My attitude will be the demonstration that an act of ours ends, is devoured, refuses to engender the next one. I pursue my death and his own. Wherever he is, under whatever roof, may a fine rain pierce him to the marrow, ravage him, but above all, may a subtle despair blur his thoughts and cut him away from any plan. He will know he is dying. Geographic distance separates us, but we will individually pursue the same death-agony. Tragic imitation of the death his microbes and his ghosts are preparing for him, mine is also real. Reflection of the other, more affected, but more painful,

it knows it is a comedy that can stop, but that—strict poem that it is—nothing will interrupt except the borders required by the order of the poem. The entire drama here will be the echo of a despair that is lived elsewhere, but elsewhere will be reflected in the echo that will come back to me. Reflection—reflecting—reflectiveness of the two suicides in slow motion that devour each other, that feed on each other and are exhausted in each other, this book also runs to its downfall, and to my own. No doubt it was a matter of the Lady of the Camellias, but in order to destroy: this Lady, her flesh, her clothes, her symbolic flowers, her name, my love, myself, up to the memory of all of that.

The most frivolous opinion, that death doubles each event, had sensed it already. Each gesture is woven from it. Knowing as inevitable the flight of everything from everything, we pursue the mistake itself. My adventure will be funereal in that every act is resolutely lived and thought not so it will engender the act that comes, but so that it will be reflected in itself, burst forth, explode, and win the most rigorous definition of itself, all the way to its annihilation. That is: the catafalque where there is no Emperor of Germany, on which a simulacrum is constructed, hollow ceremony, brief—or long—in honor of the whole absence.

Is this just a question of a simple anecdote reducible to: a pederast becomes infatuated with a young boy who deceives him? The pederast grieves, becomes enraged, hides. Ironic and sovereign, the child thinks he is strong. He fools and is fooled. He is subtle and cruel out of indifference. Those are the simple givens. The game is banal and easy.

Before knowing him, I had wanted to commit suicide. But his presence, and then his image in me, then his possible fate, coming not from him but from that image, overwhelmed me. He refused to exist according to this image. This unhappy passion soon took on an allure of catastrophe that, dizzily, could have led me to who knows what sterile act: suicide, murder, or madness.[9] I came through it for the poem. But I seem to have lived through miseries of such a baseness that I think I am coming back up from purgatory. Suicide? Hesitating between life and death, suspended in the void, awakened-asleep, I was working in sin on this hypocrite, vain death. You know? Before I knew that sick kid I had wanted to suppress myself: he is the one, that precious and savage dying one, who will become my blundered death. But why did such a fate take off from this image of him? But why, then, such an image, arising from his face and his body?

While an entertaining concern to live on the surface of the world—or, alive, to connect with the meaning of an obsession that feeds me and devours me?—suggested I raise a bloodless fairy to the stature of a thief,[10] my failure, subtly assented to, makes me modify this adventure, solve it according to inner givens, use it according to this funeral chant—secretly in harmony with the song of the thief—that will free me from it and from me in favor of the poem. It is my own destruction I am attempting, insofar as my language destroys the hero—who will die soon as a flesh and blood adolescent, but will pursue, as mythological principle, an infernal existence. Blind, a snake moves in the basalt. Him? That he lives and dies in a precise place in the

world matters little. He must rot, and his rotting must make language stink and fail.

Finally this adventure that, on the level of anecdotal fact, will be a failure at once wished for and compelled, changes into a logical pursuit that is opposed to the morality of the world, and although it tries to deny it, it borrows from it all its notions, its terms of comparison—which are copious—in order to empty them. It seeks to build a spectral civilization, but doesn't know how to use words other than those that reflect a full and continuous reality. Finally, there's an even more laughable contradiction: this system that it wants to elaborate and make coherent, that is to say, capable of facing the world, it is hatred, not love, that will have to set the measure of its inner relationships, but hatred does not connect, it isolates. Let us try.

FRAGMENTS OF A SECOND DISCOURSE

Beneath your glacial appearance, what shiver could move you?

—What's wrong?
—Nothing
—Yes
—Nothing
—You're sad
—So I'm sad
—Why
—Because I'm sad
—Why sad
—Because

What steps, carved out of hard appearance, go down backward, Shades? What preparatory simulacrum to start with? Under a clear, cold light, enter, the rooms are ready: on the facing walls, the mirrors do not multiply the play of the event, but are a prelude to its absence.

These round silences have the shape of your head, so I break them with a quick blow so that out come

One single—close to mine that grazes it—one single sex? Thousands against thousands who are mine who am thousands—move, stand still, kick gently, in these implacable mirrors, impenetrable, where the law of silence is absolute.

A thousand times the other is repeated, his cough comes out a thousand times invisible from a thousand times his gaping mouth and—except for one close to mine—a thousand times deaf and a thousand times I expire at being unable to reduce the universe to this immobile, brutal, and insane reflection!

Guards, invisible, but knowing, fortunately guard the enclosed image. Never will it come...

If only I were outside the room so I could see myself seeing myself in it!

Beneath the stream a thousand times gushing up—in the mirrors and the gilded frames—urine and its steam of an Other, indispensable, but always interchangeable,

—Nothing
—But why?
—I'm sad
—Yes?
—Because
—Why sad?
—My friend doesn't have a suit
—Why
—He gave it
Your eye aims at life
—He gave it? To whom?
—To a dead man.

thighs dripping, but confident,
torso, neck, belly too—a hand—
a thousand hands—when the
other blends in—a thousand
others blend into Absence—holds
a mirror!

Let's go on. A thousand times
the other's hand on a thousand
times my neck. A thousand
times—infinitely I move, infi-
nitely I change angles, infinitely
I am broken. . . . Cut! in the space
finally abolished by the frost. . . .
No. The mirror room is extin-
guished. Empty?

So one of yours could be properly buried, his friend offered
his only suit, and the young people made fun of him: you
fought with them. There exists, then, and you know it, above
the reason of the practical, a reason that requires you to strip
yourself to wrap some stinking meat: it is poetic reason, the
one that thrusts away the event and fixes it in the motionless
sky of language. No doubt the shameless, offending dead
man was also handsome, freeing by fracture another and
scathing poetry, but it is you who just spoke it, reduced to
suburban scale—in Roman dialect, without being careful
about it—my tender Antigone.

The mythical camellia—now in heaven—that cruelly
symbolized you, has metamorphosed into you, fateful con-
sumptive, consumptive vamp! Your glorious consumption. . . .
Beat, drums! By angles and mirrors, a villainous theater
offers us a capital execution. Ironic, you climb three steps

and come to win your periodic resurrection. What crime, that the myth preserves, leads you to your execution, offers you to the axe? Getting screwed, fucked, frees you. From what? You lick the executioner, no, you kiss him. You oil him, arouse him, overcome him. You make him cry.

Phaedra, living queen, in love with Hippolytus, there is the crime. Still she is sovereign and already out of reach, scandalous, but let her die, accept seeing her projected on the sky, looking with mortal eyes at her exiled passion offering itself to the world as an example: everything is resolved.

On your knees on the unmade bed, you offer your behind to the executioner, but the image that sums up this instant, the point of the body where your being precipitates, is your childlike neck bent on the pillow. Is it its already withered fall or an invisible hand that pulls your hair in front and mixes it with your drool, your tears, and your mucous? On your knees—but facing what god or what monumental absence?—you are executed. Become: a whore, then the sublime slut, the queen—you, faggot of the bloody spittle, the goddess, a constellation, then the name alone of that constellation, and that name a used-up sign that a poet can use. But a whore first and dying every time. Croak, or, for you alone, use your wretchedness. But facing this mysterious nothingness, you kneel down: he slices your neck when a prick sodomizes you. Mocking, your awakening is simple. Intact, smiling—and free—you walk down the platform on the executioner's arm.

Terrible shortened Mass just for you, leaning over—before this solemn absence, but renewing itself by us, the Queers, Fairies, not of birth, but of death, around your coffin twisting

our bodies. Long ago, your wretchedness, your consumption, that radiant evening, dazzled us.

This last page I want to mark with the insolent, invisible step of that cruel instant—but maybe it was still you, mocker, making fun of your next descent into hell? In front of you, or if not you, some other infernal and transparent demon come out of you as you came out of me, who dared to say that a well-cut woolen suit looks better on a svelte and mocking lout, winking, his hair ruffled by the wind, than on his corpse? Who? The invisible Unknown had your smile in his teeth when—undressing me, too, and sending me back to the tomb—you dared say to me: "My kisses? I was just teasing you."

Get up! Go die! Not for a delicious widowhood and then another wedding, it is your absolute death that I am trying for, and my own. At my disposal I had the usual means: poisons, fear (you were dead of fear when you got tiny coffins containing your disfigured image), bullets, crushing you under my car, smashing you on the rocks! With a clean blow, to kill this handsome child would not have kept his ghost from hating me and going on to animate an even more handsome body, and the irony of that would have finished me. A more subtle death is being prepared.

Translated by Charlotte Mandell

LETTER TO JEAN-JACQUES PAUVERT

My DEAR Pauvert,

So you need to have a spectacle. But what can I say of a play on which I turned my back even before it was finished? [This letter was first published as an introduction to the two versions of *Les Bonnes*, which Pauvert published.—*Trans.*] To speak of its composition would be to evoke a world and a region without greatness. The reasons that allow you to edit both versions have become uninteresting to me. I will only indicate that the second one—the most talkative one— was in fact the first. Long rehearsals pruned it, simplified it. But I would rather say a few words about theater in general. I do not like it. Reading the play will convince you of this. What I have been told of Japanese, Chinese, or Balinese ceremonies, and perhaps the inflated image of them that persists in my brain, makes the format of Western theater too coarse to me. We can only dream of an art that would be a profound labyrinth of active symbols, able to speak to the public a language in which nothing would be said, but everything felt. But any poet who attempted this adventure would be confronted with the insolent stupidity of actors and theater people. If, rarely, their triviality subsides, then their lack of culture and stupidity appear. One can expect nothing from a livelihood that is exercised with such little gravity or contemplation. Its point of departure, its reason

for being, is exhibitionism. Beginning with any kind of aberrant attitude, you can elaborate a moral code or an aesthetics—you need only courage and renunciation, and the actor's choice of livelihood is motivated by his mistaken idea that the world is not demanding, but easily pleased. The Western actor does not try to become a sign charged with signs; he just wants to identify with a tragic or comic character. The actual world, tired, unable to live in actions, leads him even more into this vulgarity by making him represent in its place not heroic themes, but dreamed-up characters. What could the morality of these people be, then? If they do not stagnate in intellectual, but bitter seediness, they work for top billing. Look at them fighting for the front page in the newspapers. So instead of founding a conservatory, we should found a sort of seminary, and then, starting from it, build theatrical constructions with all the texts, sets, gestures they must entail. For even the most beautiful Western plays have an air of chaos, of masquerade, not of ceremony. What unfolds on the set is always puerile. The beauty of the language sometimes deceives us as to the profundity of the theme. In the theater, everything happens in the visible world and nowhere else.

Commissioned by an actor who was famous in his day, my play was written, then, out of vanity, but in boredom. I abandon it to the publisher, in its two tentative versions, but may it remain a proof of inspired stupidity. Still—I am still speaking of its making—already moved by the dreary sadness of a theater that too exactly reflects the visible world, the actions of men, and not of gods, I tried to achieve a distancing that, allowing a declamatory tone, would devote the

theater to theater. I thus hoped to obtain the abolition of characters—who usually seem true only because of psychological conventions—in favor of signs that were as far as possible from what they seemed at first to signify, but still linked together, so that, by this single link, the author and spectator could be united. In short, to manage it so that these characters were nothing on the set except the metaphor of what they should represent. To bring this off, I had, of course, also to invent a tone of voice, a walk, a gesture.... It is a failure. I accuse myself, then, of abandoning myself without courage to an undertaking without risks or dangers. But I repeat that I was encouraged to do it by this universe of the spectacle that is satisfied with approximation. The work of actors stems mostly from the teaching supplied in the official conservatories. Those who dared a few experiments were inspired by the East. Alas, they do it like ordinary women practicing yoga. The manners, customs, entourage of poets are often sadly frivolous, but what can be said of those of theater people? If a poet discovers a great theme and begins to give it order, he must, to complete it, imagine it played, but if he brings to his work the rigor, the patience, the investigations, the gravity with which one approaches a poem, if he discovers major themes and profound symbols, what actors would know how to express them?

Instead of contemplation, theater people live in the dispersion of themselves. Should they be blamed? Probably this profession imposes itself on them in this facile form because, beneath the eye of a well-fed and slightly jealous public, they lounge in a life that is short, but without danger, and in a mechanical apotheosis. I know marionettes would do the job better than they. Already we are thinking of using them. Still, it might nonetheless be possible that this theatrical

formula that I summon, completely and uniquely allusive, is a personal taste of mine. Through this letter, I might be expressing nothing but my own mood.

On a stage almost the same as our own, on a dais, imagine recreating the end of a meal. Starting from this single elusive fact, the greatest modern drama has been expressed for two thousand years, every day, in the sacrifice of the Mass. The starting point disappears beneath the profusion of ornaments and symbols that still overwhelm us. Under the most familiar appearance—a crust of bread—we devour a god. Theatrically speaking, I know nothing more effective than the Elevation of the Host. When this *appearance appears* before us—but under what form, since all heads are bowed, the priest alone knows, perhaps it's God himself or a simple white wafer he holds at the tip of his four fingers?—or that other moment of the Mass when the priest, having broken up the Host on the paten, to show the faithful—not the public!—the faithful? But they still lower their heads, they pray, too?—reconstitutes it and eats it. In his mouth, the Host cracks! A performance that does not act on my soul is vain. It is vain if I do not believe in what I see, which will stop—will never have been—as soon as the curtain falls. No doubt one of the functions of art is to substitute the effectiveness of beauty for religious faith. At least, this beauty must have the power of a poem, that is to say, of a crime. Let's go on.

I spoke of Communion. The modern theater is a diversion. It sometimes, rarely, happens that it is a diversion of quality. The word somehow evokes the idea of dispersion. I do not know any plays that unite the spectators, even for an hour.

On the contrary, plays isolate them even more. Sartre told me, though, of having experienced this religious fervor during a theatrical performance: in a prisoner's camp, at Christmas, soldiers, mediocre actors, had put on a French play evoking some theme—revolt, captivity, courage?—and the distant Homeland was suddenly present not on the set, but in the room. A clandestine theater, to which one would come in secret, at night and masked, a theater in the catacombs, might still be possible. It would be enough to discover—or to create—the common Enemy, then the Homeland to preserve or find again. I do not know what the theater would be in a socialist world, I understand better what it would be with the Mau-Mau, but in the Western world, more and more affected by death and turned toward it, it can only refine in the "reflection" of the comedy of comedy, of the reflection of reflection that a ceremonial play could make exquisite and bring close to invisibility. If one has chosen to watch oneself die deliciously, one must rigorously seek out and arrange the symbols of death. Or choose to live and discover the Enemy. For me, the Enemy will never exist anywhere, no Homeland will exist, even an abstract or inner one. If I am moved, it will be by the nostalgic recollection of what there was. A theater of shadows alone would still touch me. A young writer told me of having seen in a public garden five or six little kids playing at war. Divided into two troops, they were preparing for attack. Night, they said, was coming. But it was noon in the sky. So they decided that one of them would be Night. The youngest and frailest, having become an element, was then the master of the Combat. "He" was Time, the Moment, the Ineluctable. From very far away, it seemed, he came, with the calm of a cycle, but burdened by twilight sadness and ceremony. As he approached,

the others, the Men, became nervous, anxious.... But the child, in their opinion, came too soon. He was ahead of himself: of one common accord, the Troops and the Chiefs decided to suppress Night, who became once again a soldier in a troop.... It is starting from this formula alone that a theater could delight me.

Translated by Charlotte Mandell

THE STUDIO OF ALBERTO GIACOMETTI

EVERY man has probably experienced that sort of grief, if not terror, at seeing how the world and its history seem caught in an ineluctable movement, which keeps gaining momentum and which seems able to change, toward ever coarser ends, nothing but the visible manifestations of the world. This visible world is what it is, and our action on it cannot make it be otherwise. So we think nostalgically about a universe in which man, instead of acting so furiously on visible appearances, would be employed in ridding himself of them, not just by refusing to act upon them, but by stripping himself enough to discover that secret place in ourselves from which an entirely different human adventure might possibly begin. More precisely, a moral one, no doubt. But, after all, it is perhaps to that inhuman condition, to that ineluctable arrangement, that we owe our nostalgia for a civilization that would try to venture somewhere beyond the measurable. It is Giacometti's body of work that makes our universe even more unbearable to me, so much does it seem that this artist knew how to remove whatever impeded his gaze so he could discover what remains of man when the pretence is removed. But perhaps Giacometti also needed the inhuman condition that is imposed on us so that his nostalgia could become so great that it would give him the strength to succeed in his search. Whatever the case may be, his entire

oeuvre seems to me to be this search and has to do not only with man, but also with anything at all, with the most banal of objects. And when he succeeded in ridding the chosen object or being from its utilitarian pretence, the image he gives us of it is magnificent. Well-deserved if foreseeable reward.

Beauty has no other origin than a wound, unique, different for each person, hidden or visible, that everyone keeps in himself, that he preserves and to which he withdraws when he wants to leave the world for a temporary, but profound solitude. There's a big difference between this art and what we call "sordid realism" [*misérabilisme*]. Giacometti's art seems to me to want to discover that secret wound of every being, and even of every object, so that it can illumine them.

When there suddenly appeared—for the niche is cleanly cut, level with the wall—Osiris beneath the green light, I was afraid. My eyes, naturally, were the first to know? No. My shoulders first, and the nape of my neck that a hand was crushing, or a mass that compelled me to sink into the Egyptian millennia and, mentally, to bend down, and even more, to shrivel before this small statue with the hard gaze and smile. It was indeed a question of a god. Of the god of the inexorable. (I am speaking, perhaps you've already guessed, of the statue of Osiris, standing, in the crypt of the Louvre.) I was afraid because it was a question, without any possible doubt, of a god. Certain statues by Giacometti cause an emotion in me quite close to that terror, and a fascination almost as great.

*

They also cause this curious feeling in me: they are familiar, they walk in the street. And yet they are in the depths of time, at the origin of everything, they keep coming near and moving back, in a sovereign immobility. If my gaze tries to tame them, to approach them and—without fury, without anger or wrath, simply because of a distance between them and me that I had not noticed, so compressed and reduced was it, that made me think they were really close—they move out of sight: it is because this distance suddenly unfurled between them and me. Where do they go? While their image remains visible, where are they? (I am speaking especially of the eight great statues on exhibit this summer in Venice.) [Probably Giacometti's *Femmes de Venise*, exhibited in the 1956 Venice Biennale.—*Trans.*]

I don't quite understand what in art is called an innovator. Should a work be understood by future generations? But why? And what would that mean? That they could use it? For what purpose? I don't see it. But I understand better— though very obscurely—that every work of art, if it wants to reach the most spectacular proportions, must, with infinite patience and care from the moment of its production onward, come down through the millennia, reach if it can the immemorial night peopled with the dead, who will recognize themselves in this work.

No, no, the work of art is not destined for unborn generations. It is offered to the innumerable populace of the dead. Who recognize it. Or refuse it. But these dead of whom I spoke have never been alive. Or I am forgetting. They were alive enough to be forgotten, enough so that their life's function was to make them cross to that calm shore where they

wait for a sign—one that comes from here—that they recognize.

Although present here, where are those figures of Giacometti of which I spoke, if not in death? From which they escape at each summons of our eyes to come close to us.

I say to Giacometti:

ME: One must have a strong stomach to have one of your statues in one's house.

HIM: Why?

I hesitate to answer. My sentence will piss him off.

ME: One of your statues in a room, and the room is a temple.

He seems a little disconcerted.

HIM: And you think that's good?

ME: I don't know. And you, do you think that's good?

The shoulders, especially, and the chest of two of them have the delicacy of a skeleton that, if you touch it, will crumble away. The curve of the shoulder—the joint of the arm—is exquisite...(excuse me, but) is exquisite with strength. I touch the shoulder and close my eyes: I cannot describe the happiness of my fingers. First of all, for the first time they touch bronze. Then, someone strong guides them and reassures them.

He speaks in a harsh way, he seems to take pleasure in choosing the intonations and words that are closest to ordinary conversation. Like a barrel maker.

HIM: You have seen them in plaster.... Do you remember them, in plaster?

ME: Yes.

HIM: Do you think they lose something, being in bronze?

ME: No. Not at all.

HIM: Do you think they gain something?

I still hesitate here to utter the phrase that will best express my feeling:

ME: This will piss you off again, but I have a strange feeling. I wouldn't say they gain by it, but that the bronze is what has gained. For the first time in its life, the bronze has won. Your women—they are a victory of bronze. Over itself, perhaps.

HIM: It would have to be like that.

He smiles. And all the wrinkled skin of his face begins to laugh. Strangely. The eyes laugh, of course, but the forehead, too (his entire person is the gray of his studio). Out of sympathy, perhaps, he has taken on the color of dust. His teeth laugh—spaced apart and gray, too—the wind passes through them.

He looks at one of his statues:

HIM: It's a little misshapen, isn't it?

He often says this word [*biscornu*]. He also is somewhat misshapen. He scratches his gray, tousled head. Annette has trimmed his hair. He pulls up his gray trousers that were drooping onto his shoes. He was laughing six seconds ago, but he has just touched a rough-hewn statue: for half a minute he will be wholly in the transition from his fingers to the mass of clay. I do not interest him at all.

On the subject of bronze. During a dinner, one of his friends, teasing, no doubt—who was it?—says to him:

—Frankly, could a normally constituted brain live in such a flat head?

Giacometti knew that a brain could not live in a bronze skull, even if it had the exact measurements of M. René Coty's [president of the French Republic from 1954 to 1959—*Trans.*]. And, since the head will be in bronze, and since it must live, and since the bronze must live, one must then.... It's clear, isn't it?

Giacometti still insists: his ideal is the little rubber fetish statues they sell to South Americans in the lobby of the Folies-Bergère.

HIM: When I'm walking down the street and I see some chick, far away and all dressed up, I just see a chick. When she's in the room and completely naked in front of me, I see a goddess.

ME: For me, a nude woman is a nude woman. That hardly impresses me. I am quite incapable of seeing her as a goddess. But I see your statues as you see nude chicks.

HIM: Do you think I succeed in showing them as I see them?

This afternoon we are in the studio. I notice two canvases—two heads—of an extraordinary acuity, they seem to be in the midst of walking, coming to meet me, never stopping this motion toward me, and from I can't tell what depths of the canvas that keep expressing this sharp face.

HIM: It's a beginning, right?

He questions my expression. Then, reassured:

HIM: I made them the other night. From memory.... I

also made some sketches (*he hesitates*) ... but they're no good. Do you want to see them?

I must have answered strangely, so stupefied was I by the question. In the four years that I've been regularly seeing him, this is the first time he has offered to show me one of his works. The rest of the time he sees to it—a little surprised—that I see and admire.

So he opens a box and takes out six drawings, four of which are especially admirable. One of the ones that touched me the least shows a person of very small stature, placed at the very bottom of an immense white sheet.

HIM: I'm not very happy with it, but it's the first time I've dared to do that.

Perhaps he means to say: Emphasize such a great white surface with the help of such a tiny person? or: Show that the proportions of a person resist the crushing attempt made by an enormous surface? Or ...

Whatever he wanted to attempt, his thought moves me, coming from a man who doesn't stop taking risks. This little person, here, is one of his victories. What must he have conquered, Giacometti, that was so threatening?

When previously I said "for the dead," it was so that that innumerable crowd finally gets to see what they could not see when they were alive, standing up in their bones. There must be an art—not fluid, but on the contrary, very hard—gifted with the strange power to penetrate that realm of death, perhaps to seep through the porous walls of the kingdom of shadows. The injustice—and our pain—would be too great if one single shade were deprived of the knowledge of a single one of us, and our victory would be poor indeed

if it did not let us earn a future glory. To the people of the dead, Giacometti's work communicates the knowledge of the solitude of each being and each thing, and that this solitude is our surest glory.

A work of art cannot be approached—who ever thought it could?—like a person, like a living being, or like another natural phenomenon. The poem, the painting, the statue need to be examined with a certain number of qualities. But let us talk about the painting.

A living face does not give itself over so easily, but the effort to discover its significance is not too great. I think— I venture—I think it is important to isolate it. If my gaze makes it escape everything that surrounds it, if my gaze (my attention) prevents this face from being confused with the rest of the world and from escaping ad infinitum into ever vaguer meanings, outside of itself, and if, on the other hand, this solitude by which my gaze cuts it off from the rest of the world is won, it is its meaning alone that will flow and pour into that face—or that person, or that being, or that phenomenon.—I mean that knowledge of a face, if it is supposed to be aesthetic, must refuse to be historical.

To examine a painting, a greater effort and a more complex operation are necessary. It is in fact the painter—or the sculptor—who has carried out for us the operation described above. It is thus the solitude of the person or the object represented that is restored to us, and we, who look, in order to perceive it and be touched by it must have an experience of space—not of its continuity, but its discontinuity.

Each object creates its infinite space.

If I look at the painting, as I said, it appears to me in its absolute solitude of object as painting. But that is not what preoccupies me. Rather, it is what its canvas must represent. So it is at once the image that is on the canvas—and the actual object it represents that I want to grasp in their solitude. So I must first try to isolate in its significance the painting as material object (canvas, frame, etc.), so that it stops belonging to the immense family of painting (even if it means bringing it back to that later on), but so that the image on the canvas becomes linked to my experience of space, to my knowledge of the solitude of objects, beings, or events as I described it above.

Whoever has never been filled with wonder at this solitude will not know the beauty of painting. If he claims to, he is lying.

Each statue, clearly, is different. I know only the statues of women for which Annette posed, and the busts of Diego—and each goddess and that god—here I hesitate: if, before these women, I have the feeling of facing goddesses—goddesses and not the statue of a goddess—Diego's bust never reaches that height, never even now, it does not withdraw—to return at a terrible speed—to that distance of which I was speaking. It is rather the bust of a priest belonging to the very high clergy. Not a god. But each statue, so different, is always linked to the same high, somber family. Familiar and very close. Inaccessible.

Giacometti, to whom I am reading this text, asks me why, in my opinion, this difference of intensity between the statues of women and the busts of Diego.
 ME: *Maybe—(I hesitate to answer for a long time)…*

maybe because, despite everything, woman seems to you naturally more far away ... or else you want to make her withdraw ...

Despite myself, without saying anything to him, I recall the image of the Mother, placed so high up, or, what do I know?

HIM: *Yes, maybe that's it.*

He continues reading—I, my fading thought—but he raises his head, takes his broken, dirty glasses off his nose.

HIM: *Maybe it's because the statues of Annette show the whole individual, while Diego is only his bust. He is cut. Thus conventional. And it's that convention that makes him less distant.*

His explanation seems true to me.

ME: *You're right. It "socializes" him.*

Tonight, as I write this note, I am less convinced by what he said to me, for I do not know how he would model the legs. Or rather the rest of the body, for in such a sculpture, each organ or member is at that point of prolongation of all the others in order to form the indissoluble individual, so that it loses even its name. "This" arm cannot be imagined without the body that continues it and signifies it to the extreme (the body being the prolongation of the arm), and yet I know no arm more intensely, more expressly arm than that one.

This resemblance, it seems to me, is not due to the artist's "style." It is because each figure has the same origin, no doubt nocturnal, but well placed in the world.

Where?

*

About four years ago, I was on the train. Opposite me in the compartment, an appalling old man was sitting. Dirty, and, obviously, mean, as some of his remarks proved to me. Refusing to pursue an unfruitful conversation with him, I wanted to read, but despite myself, I looked at the little old man: he was very ugly. His gaze crossed, as they say, mine, and, although I no longer know if it was short or drawn-out, I suddenly knew the painful—yes, painful—feeling that any man was exactly—sorry, but I want to emphasize "exactly"—"worth" any other man. "Anyone at all," I told myself, "can be loved beyond his ugliness, his stupidity, his meanness."

It was a gaze, drawn-out or quick, that was caught in my own and that made me aware of that. And what causes a man to be loved beyond his ugliness or his meanness allows one to love precisely those things, his ugliness and meanness. Do not misunderstand: it was not a question of a goodness coming from me, but of a recognition. Giacometti's gaze saw that a long time ago, and he restores it to us. I say what I feel: this connection revealed by his figures seems to be that precious point at which the human being is brought back to the most irreducible part of him: his solitude of being exactly equivalent to every other human being.

If—Giacometti's figures being incorruptible—the accident is annihilated, what then remains?

Giacometti's bronze dog is admirable. It was even more handsome when its strange substance—plaster, mixed with string or twine—crumbled away. The curve, without marked articulation and yet perceptible, of his front paw is so beautiful that it alone decides the supple walk of the dog. For it strolls, sniffing, its muzzle resting on the ground. It is thin.

I had forgotten the admirable cat: in plaster, from muzzle to tip of tail, almost horizontal and capable of passing through a mouse-hole. Its rigid horizontality perfectly reproduced the shape a cat keeps, even when it is curled up.

As I am surprised that there is an animal—it's the only one among his figures:

HIM: It's me. One day I saw myself in the street like that. I was the dog.

If it was first chosen as a sign of misery and solitude, it seems to me that this dog is drawn as a harmonious signature, the curve of the spine answering the curve of the paw, but this signature is also the supreme magnification of solitude.

This secret region, this solitude where beings—and things, too—take refuge, it is this that gives so much beauty to the street; for instance: I am in the bus, sitting there, I just have to look out. The bus is hurtling downhill along the street. I'm going too fast to be able to linger over a face or a gesture, my speed requires a corresponding speed from my gaze, so there isn't one face, one body, one attitude prepared for me: they are naked. I note: a very tall, very thin man, stooping, chest hollow, glasses and long nose; a fat housewife walking slowly, heavily, sadly; an old man who is not a handsome old man, a tree that is alone, next to a tree that is alone, next to another...; an office worker, another one, a multitude of office workers, an entire city peopled with bent office workers, wholly gathered into this detail of themselves that my gaze notes: a fold of the mouth, a tiredness in the shoulders... each of their attitudes, perhaps because of the speed of my gaze and of the vehicle, is sketched so quickly, so quickly grasped in its arabesque, that each being is revealed to me

in its newest, most irreplaceable quality—and it's still a wound—thanks to the solitude where this wound places them, about which they know almost nothing, and yet into which their entire being flows. I thus cross a city sketched by Rembrandt, where each person and each thing is grasped in its truth, which leaves plastic beauty far behind. The city—made of solitude—would be the most perfect form of life, except that my bus passes some lovers crossing a square: they hold each other by the waist, and the girl has devised the charming gesture of placing her little hand in the hip pocket of the boy's jeans, so now this pretty and self-conscious gesture vulgarizes a page of masterpieces.

Solitude, as I understand it, does not mean a miserable condition, but rather a secret royalty, a profound incommunicability, but a more or less obscure knowledge of an unassailable singularity.

I cannot prevent myself from touching the statues: I turn away my eyes, and my hand continues its discoveries alone: the neck, the head, the nape of the neck, the shoulders...Sensations flow to my fingertips. Not one that isn't different, so that my hand travels through an extremely varied and lively landscape.

FREDERICK II (*I think, listening, I think, to Mozart's* Magic Flute): Too many notes, too many notes!

—Sire, there isn't one too many.

My fingers remake what Giacometti's made, but while his sought support in wet plaster or clay, mine confidently put their steps back in his. And—finally!—my hand lives, my hand sees.

*

Their beauty—Giacometti's sculptures—seems to me to stem from the incessant, uninterrupted to-and-fro movement from the most extreme distance to the closest familiarity: this to-and-fro doesn't end, and that's how you can tell they are in movement.

We go have a drink. His is coffee. He stops to take better notice of the keen beauty of the Rue d'Alésia, such a light beauty, thanks to the locust trees, whose keen foliage, sharpened by transparency, in the sun more yellow than green, seems to suspend a gold powder above the street.

HIM: It's pretty, pretty...

He resumes walking, limping. He tells me he was very happy when he found out that his operation—after an accident—would leave him lame. That is why I will chance this: his statues still give me the impression that they are taking refuge, finally, in some secret infirmity that grants them solitude.

Giacometti and I—and no doubt a few Parisians—know that there exists in Paris, where her home is, a person of great elegance, fine, haughty, sheer, singular, and gray—of a very tender gray: the Rue Oberkampf, which, casually, changes its name and calls itself higher up the Rue de Ménilmontant. Beautiful as a needle, it rises up to the sky. If one decides to traverse it by car, starting from the Boulevard Voltaire, as one climbs, it opens up, but in a curious way: instead of being farther apart, the houses come closer together, offering very simple façades and gables, of a great banality, but which, actually transfigured by the personality of this street, are

flushed with a sort of goodness, familiar and faraway. Not long ago they put imbecilic little dark-blue discs on it, crossed by a red bar, supposed to indicate that parking is forbidden. Is the street spoiled, then? It is even more beautiful. Nothing—nothing!—could make it ugly.

How did it happen? Where did it dig up such a noble sweetness? How can it be at once so tender and so faraway, and how is it that one approaches it with respect? I hope Giacometti will pardon me, but it seems to me that this almost standing street is none other than one of his great statues, at once anxious, trembling, and serene.

It is not until the feet of the statues . . .

A word here: except for the men walking, all Giacometti's statues have feet that look as if they were caught in one single, sloping block, very thick, that somewhat resembles a pedestal. From there, the body supports far off, high up, a minuscule head. This enormous—proportionally to the head—mass of plaster or bronze could make one think that these feet are charged with all the materiality of which the head rids itself . . . not at all; from these massive feet to the head an uninterrupted exchange takes place. These ladies do not wrench themselves out of a heavy mud: at twilight, they're going to slide down a slope drowned in shadow.

His statues seem to belong to a former time, to have been discovered after time and night—which worked on them with intelligence—had corroded them to give them that both sweet and hard feeling of *eternity that passes*. Or rather, they emerge from an oven, remnants of a terrible roasting: once the flames were extinguished, it had to remain that way.

But what flames!

Giacometti tells me that he once had the idea of molding a statue and burying it. (Immediately one thinks: "May the earth rest lightly on it.") Not so that it could be discovered by someone, even much later, when he himself and even the memory of his name have disappeared.

Would burying it be to offer it to the dead?

On the solitude of objects.

HIM: One day, in my room, I was looking at a napkin placed on a chair, and I actually had the impression that, not only was each object alone, but that it had a weight—or rather an absence of weight—that prevented it from weighing on another object. The napkin was alone, so alone that I had the impression of being able to lift the chair without the napkin changing place. It had its own place, its own weight, even its own silence. The world was light, light...

If he had to give a present to someone he respected or loved, he might send her, certain of honoring her, gathered at the carpenter's, a curled shaving or a piece of birch bark.

His canvases. Seen in the studio (somewhat dark. Giacometti respects all substances to such a point that he would be angry if Annette destroyed the dust on the windows), for I can keep only a little distance, the portrait seems to me first like a tangle of curved lines, commas, closed circles crossed by a secant, mostly pink, gray, or black—a strange green is also mixed in—a very delicate tangle he was in the process of making, in which he no doubt lost himself. But I have the idea of taking the painting out into the courtyard: the result is frightening. As I move away (I will go so far as

to open the door to the courtyard and go out into the street, retreating to sixty or seventy feet away) the face, with all its contours, appears to me, imposes itself—according to that already described phenomenon unique to Giacometti's figures—comes to meet me, swoops down on me, and hurries back into the canvas from which it came, becomes a terrible presence, reality, and form.

I said "its contours," but it is something else. For he never seems to be preoccupied with tones, or shadows, or conventional values. So he achieves a linear system that might only be drawings inside the drawing. But—and I don't really understand this—while he never sought contours with shadows or tones, or with the methods of any pictorial convention, somehow he achieves the most extraordinary depth. If I examine the canvas more closely, "contours" isn't right. It is rather a question of an unbreakable hardness the figure has obtained. It seems to have an extremely great molecular weight. It hasn't been brought to life, like some figures that are described as living because they were grasped in a particular instant of their movements, because they are shown by an accident that belongs to their history alone, but it is almost the opposite: the faces painted by Giacometti seem to have accumulated all life to the point that not one second more remains for them to live, or one gesture to make, and (not that they have just died) that they finally know death, for too much life is amassed in them. Seen sixty feet away, each portrait is a small mass of life, hard as a pebble, full as an egg, which could effortlessly feed a hundred other portraits.

As he paints: he refuses to establish a difference of "level"—or surface—between the different parts of the face. The same line, or the same ensemble of lines, can serve for the cheek, the eye, and the eyebrow. For him, eyes are not blue, cheeks

pink, eyebrow black and curved: there is a continuous line that is made up of the cheek, the eye, and the eyebrow. There is no shadow of the nose on the cheek, or, rather, if it exists, this shadow must be treated as a part of the face, with the same traits, curves, valid here or there.

Placed in the midst of old bottles of solvent, his palette, in the final days: a puddle of mud of different grays.

This capacity to isolate an object and make its own, its unique significations flow into it is possible only through the historical abolition of the one who is looking. He must make an exceptional effort to divest himself of all history, so that he becomes not a sort of eternal present, but rather a vertiginous and uninterrupted passage from a past to a future, an oscillation of one extreme to another, preventing rest.

If I look at the armoire to know *finally* what it is, I eliminate all that is not it. And the effort I expend makes me a curious being: this being, this observer, stops being present, or even being a present observer: he continues to withdraw into an indefinite past and future. He stops being there so that the armoire can remain and so that between the armoire and him all emotional or utilitarian relationships are abolished.

(September '57.) The most beautiful statue by Giacometti—I'm speaking of three years ago—I discovered beneath the table, as I was bending down to pick up my cigarette butt. It was covered in dust, he was hiding it, a clumsy visitor's foot could have nicked it . . .

HIM: If it's really strong, it will show itself, even if I hide it.

HIM: It's lovely! … it's *love-ly*! …

In spite of his wishes to the contrary, he has preserved a little of the accent of the Grisons [Giacometti's home canton in Switzerland—*Trans.*]. … It's lovely! his eyes open wide, his smile is endearing; he was speaking of the dust covering all the old bottles of solvent that cluttered a table in the studio.

The bedroom, Annette's and his, is adorned with a pretty red-tiled floor. Previously, the floor had been stamped earth. It rained in the room. That is why, with a heavy heart, he resigned himself to the tiling. The prettiest, but humblest possible. He tells me that he will never have another dwelling besides this studio and bedroom. If it were possible, he would want them even more modest.

Lunching one day with Sartre, I repeat to him my saying on the statues: "It's the bronze that has gained."

"That is what could give him the greatest pleasure," Sartre tells me. "His dream would be to disappear completely behind his work. He would be even happier if the bronze, on its own, had manifested itself."

In order better to tame the work of art, I usually use this trick: I place myself, a little artificially, in a state of naivety; I speak of it—and to it, too—in the most ordinary way, I even babble a little. First I draw near. I speak to you of the noblest works—and I force myself to become more naive and clumsy than I am. Thus I try to divest myself of my timidity.

"How funny that is...that's red...there's some red... and there's some blue...and you might say the painting was of mud..."

The work loses a little of its solemnity. By means of a familiar recognition, I gently approach its secret....With Giacometti's work, there's nothing to do. It is already too distant. Impossible to feign a nice stupidity. Sternly, it orders me to that solitary point from which it must be seen.

His drawings. He draws only with pen or hard pencil—the paper is often pitted, torn. The curves are hard, without softness, without gentleness. It seems to me that a line for him is a man: he treats it as an equal. Broken lines are sharp and give his drawing—thanks again to the granitic and paradoxically muffled substance of the pencil—a sparkling appearance. Diamonds. Diamonds all the more because of his way of using the white spaces. In the landscapes, for instance: the whole page could be a diamond of which one side is visible, thanks to broken and subtle lines, while the side on which the light falls—or, more precisely, from which the light would be reflected—will not let us see anything else but white. That makes for extraordinary jewels—one thinks of Cézanne's watercolors: thanks to these white spaces, where an invisible drawing can be implicitly understood, the sensation of space is obtained with a strength that makes this space almost measurable. (I was thinking especially of the interiors, with their suspended ceiling lights, and of the palm trees, but since then, he has made a series of four drawings representing a table in a vaulted hall that leave the ones I was recalling far behind.) Extraordinarily chiseled gems. And it's white—the white page—that Giacometti has chiseled.

*

About the four great drawings representing a table.

In certain canvases (Monet, Bonnard...) air circulates. In the drawings I speak of, how can I say it ... space circulates. Light, too. Without any of the conventional oppositions of value—shadow-light—light radiates, and a few lines sculpt it.

Giacometti's tussles with a Japanese face. The Japanese professor Yanaihara, whose portrait he was making, had to postpone his departure by two months, since Giacometti was never satisfied with the painting he began again every day. The professor returned to Japan without his portrait. This face without sharp edges, but serious and gentle, must have tried his genius. The paintings that survive are of an admirable intensity: a few gray, almost white lines on a gray, almost black background. And that same accumulation of life of which I spoke earlier. No way to make it hold anything else, not even one grain of life more. They are at that ultimate point where life resembles inanimate matter. Breathed faces.

I pose. He draws with precision—without artfully arranging them—the stove with its chimney, which are behind me. He knows he must be exact, faithful to the reality of objects.

HIM: One must make exactly what is in front of one.

I say yes. Then, after a moment of silence:

HIM: And, in addition, one must also make a painting.

He misses the brothels that have disappeared. I think they held—and their memory still holds—too much importance

in his life for one not to speak of them. It seems to me he entered them almost as a worshipper. He came there to see himself on his knees opposite an implacable and distant divinity. Between each naked whore and him, there was perhaps this same distance that each of his statues keeps establishing between themselves and us. Each statue seems to withdraw into—or come from—a night so distant and dense that it is confused with death: thus each whore should return to a mysterious night where she was queen. And he, abandoned on a shore from which he sees her grow at once shorter and taller at the same time.

I'll risk this too: isn't it at the brothel that a woman can take pride in a wound that will never again free her from solitude, and isn't it the brothel that will rid her of any utilitarian purpose, thus making her win a sort of purity.

Many of his great statues are gilded.

During the entire time he struggled with Yanaihara's face (one can imagine the face offering itself and refusing to let its resemblance pass onto the canvas, as if it had to defend its unique identity), I had the moving spectacle of a man who never made a mistake, but who got lost all the time. He kept sinking into the distance, into impossible regions, without any way out. These days he has come back. His work is still at once darkened and dazzled by those regions. (The four great drawings of the table immediately follow that time.) Sartre tells me:

SARTRE: I saw him during the Japanese time, things weren't going well.

ME: He still says that. He is never happy.

SARTRE: Back then, he was really desperate.

About the drawings, I wrote: "Infinitely precious objects...."
I meant also that the white spaces give the page an Oriental
quality—or one of light—the lines used not so that they take
on a significant value, but with the sole purpose of giving
all significance to the white spaces. The lines are there only
to give form and solidity to the white spaces. Look carefully:
it is not the line that is elegant, it is the white space contained
by it. It is not the line that is full, it is the white space.

And why is that?

Maybe because besides the palm tree or the suspended
ceiling lights—and the very particular space in which they
are inscribed—that he wants to restore to us, Giacometti is
trying to give a perceptible reality to what was only absence—
or if you like, indeterminate uniformity—that is to say, the
white space, and even, more profoundly, the sheet of paper.
It seems, once again, that he has given himself the mission
of ennobling a sheet of white paper that, without his lines,
would never have existed.

Am I mistaken? That's possible.

But while he pinned the white sheet in front of him, I
had the impression that he has as much respect and restraint
faced with its mystery as he does when faced with the object
he is going to draw.

(I had already noted that his drawings recalled typography
on the page: [Mallarmé's] "A Throw of the Dice.")

The entire work of the sculptor and painter could be
entitled, "The invisible object."

Not only do the statues come straight up to you, as if they

had been very far away, from the depths of an extremely distant horizon, but wherever you are in relation to them, they arrange themselves so that you, who are looking at them, are at their feet. In the very back of a distant horizon, they are on an eminence, and you at the foot of the mound. They come, impatient to rejoin you and to go beyond you.

For I keep coming back to those women, now in bronze (for the most part gilded and patina'd): around them space vibrates. Nothing is at rest anymore. It may be because each angle (made with Giacometti's thumb when he was working the clay) or curve, or bump, or ridge, or shattered tip of metal is itself not at rest. Each of them continues to emit the sensibility that created them. No point or edge that cuts, tears apart space, is dead.

The back of these women, though, is perhaps more human than their front. The nape of the neck, the shoulders, the curve of the haunch, the buttocks, seem to have been modeled more "amorously" than the entire front. Seen in three-quarter profile, this movement back and forth between woman and goddess is perhaps what is most troubling. The emotion is sometimes unbearable.

For I could not prevent myself from coming back to that populace of gilded—and sometimes painted—sentries that, standing, motionless, keep watch.

Next to them, how Rodin's statues or Maillol's are close to belching, then falling asleep!

The statues (those women) of Giacometti keep watch over a dead man.

The man walking, spindly. His foot folded back. He will never stop. And he walks well and truly on earth, that is, on a sphere.

When it got around that Giacometti was doing my portrait (I would get a rather round, thick face) they told me: "He's going to make your head into a knife blade." The clay bust is still not finished, but I think I know why he used, for the different paintings, lines that seem to flee out from the median line of the face—nose, mouth, chin—toward the ears and, if possible, down to the neck. This is, it seems to me, because a face offers all the force of its significance when it is frontal, and everything must go from this center to nourish and fortify what is behind, hidden. I hate saying it so poorly, but I have the impression—as when one pulls one's hair back from the forehead and temples—that the painter pulls back (behind the canvas) the meaning of the face.

The busts of Diego *can* be seen from any vantage: three-quarters, profile, back... they *must* be seen from the front. The significance of the face—its profound resemblance—instead of accumulating on the face, flees away, sinks into the infinite, into a place never reached, behind the bust.

(It goes without saying that I am above all trying to pinpoint an emotion, to describe it, not to explain the artist's techniques.)

One of Giacometti's remarks, often repeated:
—You have to value [*il faut valoriser*]...

I do not think he has ever once, one single time in his life, regarded a being or a thing with scorn. Everyone must appear to him in his most precious solitude.

HIM: I will never manage to put all the force there is in a head into a portrait. The mere act of living already demands such a will and such energy...

Faced with his statues, another feeling: these are all very beautiful people, but it seems to me that their sadness and solitude are comparable to the sadness and solitude of a deformed man who, suddenly naked, saw his deformation displayed, which at the same time he offered to the world in order to expose his solitude and glory. Which are unchangeable.

A few of Jouhandeau's characters have this naked majesty: Prudence Hautechaume.

Well-known and endlessly new joy of my fingers when I walk them—eyes closed—over a statue.

—No doubt, I tell myself, every bronze statue gives the same happiness to the fingers. At the house of friends who own two small statues, exact copies of Donatello, I want to recommence the experiment on them: the bronze no longer responds, mute, dead.

Giacometti, or the sculptor for the blind.

But ten years ago, I had already known the same pleasure when my hand, my fingers and palm, traveled over his floor lamps. It is indeed Giacometti's hands, not his eyes, that make his objects, his figures. He does not dream them, he experiences them.

*

He falls in love with his models. He loved the Japanese man.

His concern for the layout of a page seems to correspond to the feeling I indicated earlier: to ennoble the sheet of paper or the canvas.

At the café. While Giacometti is reading, a wretched, almost blind Arab causes a stir by calling one customer after another an asshole.... The insulted customer looks fixedly at the blind man, angrily makes his jaw twitch, as if he were chewing his rage. The Arab is thin, seems imbecilic. He bumps into an invisible, but solid, wall. He understands nothing in the world where he is blind, weak, and imbecilic, he swears at it in any of its manifestations.

—If you didn't have your white cane...! shouts the Frenchman the Arab called an asshole.... I am secretly impressed that a white cane can make this blind man holier than a king, stronger than the most athletic butcher.

I offer the Arab a cigarette. His fingers look for it, find it a little by chance. He is small, thin, dirty, also a little drunk, stammering, drooling. His beard is sparse and badly shaved. There don't seem to be legs in his pants. So he scarcely keeps himself upright. A wedding ring on his finger. I say a few words in his language:

—You're married?

Giacometti continues his reading and I do not dare disturb him. My attitude with the Arab annoys him, maybe.

—No...I don't have a wife.

As he tells me that, the Arab makes an up-and-down motion with his hand to show me that he masturbates.

—No…no wife….I have my hand…and with my hand…
no, there's nothing, nothing but my napkin…or the sheets…

His white eyes, drained of color, sightless, are endlessly
in motion.

—and I will be punished…the good God will punish
me…you don't know everything I've done…

Giacometti has finished his reading, he takes off his bro-
ken glasses, puts them in his pocket, we go out. I'd like to
comment on the incident, but how would he respond, what
would I say? I know that he knows as well as I do that this
wretched man preserves, maintains—along with his rages
and furies—the point that makes him identical to everyone
and more precious than the rest of the world: what survives
when he steps back into himself, as far as possible, as when
the sea withdraws and abandons the shore.

I mentioned this anecdote because it seems to me that
Giacometti's statues have withdrawn—abandoning the
shore—to that secret place, which I can neither describe nor
clarify, but which causes each man, when he takes refuge in
it, to be more precious than the rest of the world.

Well before that, Giacometti had told me of his amorous
adventures with an old homeless woman, charming and in
rags, probably dirty, and when she was entertaining him, he
could see growths studding her almost bald skull.

HIM: I liked her, you know. When she didn't appear for
two or three days, I went out into the street to see if she
was coming…. She was worth all the beautiful women,
wasn't she?

ME: You should've married her, and presented her as Mrs.
Giacometti.

He looks at me, smiles a little:

HIM: You think so? If I'd done that, I would've cut a fine figure, wouldn't I?

ME: Yes.

There must be a connection between these severe, solitary figures and Giacometti's taste for whores. Thank God not everything is explainable, and I don't clearly see this connection, but I feel it. One day he tells me:

HIM: What I like about hookers is that they serve no purpose. They are there. That's all.

I do not think—I may be mistaken—that he ever painted one of them. If he had to, he would find himself faced with a being with its solitude to which another kind of solitude, which springs from despair, or vacuity, is added.

Strange feet or pedestals! I'll go back to them. Here it seems (at first sight, at least) that Giacometti observes—and I hope he'll forgive me—not just the demands of statuary and its laws (knowledge and reconstruction of space), but a private ritual according to which he will give the statue an authoritarian, landowner, feudal base. The effect of this base, on us, is magical.... (They'll tell me that the whole figure is magical, yes, but the anxiety, the bewitchment that come to us from this fabulous clubfoot, is not the same as the rest. Frankly, I think here there is a rupture in Giacometti's craft: admirable in both ways, but opposite each other. With the head, the shoulders, the arms, the pelvis, he enlightens us. With the feet, he enchants us.)

*

If he—Giacometti—could crush himself to powder, to dust, how happy he'd be!

—But the "chicks"?

It is hard for dust to win, to conquer the hearts of "chicks." He'd maybe nestle in the folds of their skin, so they could have a little dirt.

Since Giacometti allows me to choose—after a pause that didn't seem to have to end before my death or his own—I decide on a small head of me (here, a parenthesis) this head in fact is very small. Alone in the canvas, it measures no more than seven centimeters by three and a half or four, but it has the *strength, weight, and dimensions* of my actual head. When I take the painting out of the studio to look at it, I am disturbed, for I know I am as much in the canvas as facing it, looking at it—so I decide on this little head (full of life, and so heavy it seems like a small ball of iron during its trajectory).

HIM: Good, I'll give it to you. (*He looks at me.*) No kidding. It's yours. (*He looks at the canvas and says more vigorously, as if he were tearing out a nail:*) It's yours. You can take it away.... But later on . . . I have to add a piece of canvas to the bottom.

Now that he shows it to me, this correction does in fact seem necessary, but as much for the canvas itself that my little head shortens as for the head that thus takes on all its weight.

I am seated, very straight, immobile, rigid (if I move, he'll quickly bring me back to order, silence, and rest) on a very uncomfortable kitchen chair.

HIM, *looking at me wonderingly*: "How handsome you

are!"—He gives two or three brush strokes to the canvas without, it seems, ceasing to pierce me with his gaze. He murmurs again, as if to himself: "How handsome you are." Then he adds this observation, which amazes him even more: "Like everybody else, right? Neither more, nor less."

HIM: When I go for a walk, I never think of my work.

That may be true, but as soon as he enters his studio, he works. In a curious way, too. He is both striving for the realization of the statue—thus outside this place, outside all approach—and present. He doesn't stop sculpting.

Since these days the statues are very tall, standing in front of them—in brown clay—his fingers climb and descend like a gardener's trimming or grafting a climbing rose bush. The fingers play all along the statue. And it's the whole studio that vibrates and lives. I experience the curious impression that, if he is there, without his touching them, the old statues, already completed, are changed, transformed, because he works on one of their sisters. This studio, moreover, on the ground floor, will collapse at any given moment. It is made of worm-eaten wood, of gray powder, the statues are of plaster, showing string, oakum, or a tip of metal wire, the canvases, painted in gray, long ago lost the tranquility they had at the paint store, everything is stained and secondhand, everything is precarious and about to collapse, everything is ready to dissolve, everything floats: but all of that is as if seized in an absolute reality. When I have left the studio, when I'm in the street, then everything around me stops being real. Should I say it? In this studio, a man is slowly dying, is wasting away, and beneath our eyes is being metamorphosed into goddesses.

Giacometti does not work for his contemporaries or for future generations: he makes statues that finally delight the dead.

Did I say this already? Every object drawn or painted by Giacometti offers us, addresses us with, his friendliest, most affectionate thinking. Never does he appear in a disconcerting form, never does he want to seem a monster! On the contrary, from very far away he brings a sort of friendship and peace that are reassuring. Or, if they are disturbing, it is because they are so pure and rare. Being in harmony with such objects (apple, bottle, suspended ceiling light, table, palm tree) demands the rejection of all compromises.

I write that a kind of friendship shines from the objects, that they address us with a friendly thought. . . . That's exaggerating a little. Of Vermeer, that might be true. Giacometti is something else: it's not because it has made itself "more human"—because it's usable and endlessly used by man—that the object painted by Giacometti moves and reassures us, it's not because the best, kindest, most sensitive of human presences has handled it, but on the contrary, because it is "that object" in all its naive freshness as object. Itself and nothing else. Itself in its total solitude.

I said that very badly, didn't I? Let's try again: it seems to me that in order to approach objects, Giacometti's eye, and then his pencil, strip themselves of all servile premeditation. On the pretext of ennobling it—or debasing it, according to the present fashion—he (Giacometti) refuses to impose

on the object the tiniest human—be it delicate, cruel or strained—nuance.

Looking at a ceiling light, he says:

"It's a ceiling light, that's It." And nothing more.

And this sudden observation illuminates the painter. The ceiling light. On paper, it will exist in its most naive bareness.

What a respect for objects. Each one has its beauty because it is "alone" in existing, there is the irreplaceable in it.

Giacometti's art is not, then, a social art because it establishes a social link—man and his secretions—between objects; it's rather an art of high-class tramps, so pure that what could unite them might be a recognition of the solitude of every being and every object. "I am alone," the object seems to say, "thus caught in a necessity against which you can do nothing. If I am nothing but what I am, I am indestructible. Being what I am, unreservedly, my solitude knows yours."

Translated by Charlotte Mandell

THE TIGHTROPE WALKER

for Abdallah

A GOLD sequin is a tiny disc of gilt metal, pierced with a hole. Thin and light, it can float on water. Sometimes one or two remain stuck in the curls of an acrobat.

This love—almost desperate, but charged with tenderness— that you must show for your wire, will have as much strength as the metal wire has to carry you. I know objects, their malignancy, their cruelty, their gratitude, too. The wire was dead—or if you like, mute, blind—but now that you are here, it will live and speak.

You will love it, with an almost carnal love. Each morning, before practice, when it is stretched out and vibrating, go give it a kiss. Ask it to support you, and that it grant you the elegance and nervousness of the hollow of the knee. At the end of the session, salute it, thank it. When it is still rolled up, at night, in its box, go see it, caress it. And, quietly, place your cheek against its own.

Some tamers use violence. You can try to tame your wire.

Be careful. The metal wire, like the panther and like, they say, the public, loves blood. Win it over, instead.

A blacksmith—only a blacksmith with gray mustache and large shoulders can risk such delicacy—each morning he greeted his beloved, his anvil, thus:

—So, my beauty!

In the evening, the day over, his big paw would caress it. The anvil was not indifferent to this, and the blacksmith was aware of its feelings.

Give your metal wire the most beautiful expression, not of you, but of it. Your leaps, your somersaults, your dances—in acrobat slang, your pitter-patter, bows, midair somersaults, cartwheels, etc.—you will execute them successfully, not for you to shine, but so that a steel wire that was dead and voiceless will finally sing. How grateful it will be to you if you are perfect in your performance, not for your glory, but its own.

May the amazed audience applaud it:

—What a surprising wire! How it supports its dancer and how it loves him!

In its turn, the wire will be the most amazing dancer of you.

The ground will make you stumble.

Who before you ever understood what nostalgia rests enclosed in the soul of a seven-millimeter steel wire? And that it knew

it was summoned to make a dancer leap with two turns in the air, with fouettés? Except for you, no one. Know its joy, then, and its gratitude.

I would not be surprised, when you walk on the earth, if you fall and sprain something. The wire will carry you better, more surely, than a road.

Nonchalantly, I open his wallet and leaf through it. Among old photos, pay stubs, expired bus tickets, I find a folded piece of paper on which he has drawn curious signs: a straight line, which represents the wire, with slanting marks to the right and left—those are his feet, or rather the place his feet would take, it is the steps he will take. And opposite each mark, a number. Because he works to bring rigors, quantitative discipline, to an art that had been subject only to a haphazard and empirical training, he will conquer.

What do I care, then, if he knows how to read or not? He knows figures well enough to measure the rhythms and numbers. Clever with numbers, Joanovici was an illiterate Jew—or Gypsy. He earned a huge fortune during one of our wars by selling scrap metal.

"A deadly solitude [*une solitude mortelle*]..."

At the bar, you can crack jokes, drink with whomever you like, with anyone at all. But when the Angel is announced, stand alone to receive him. The Angel, for us, is evening, fallen on the dazzling arena. If your solitude, paradoxically, is spotlighted, and the darkness made up of thousands of eyes judging you, fearing and hoping for your fall, it matters

little: you will dance on in a desert solitude, blindfolded, if you can, eyelids fastened shut. But nothing—especially not applause or laughter—will keep you from dancing for your image. You are an artist—alas—you can no longer deny yourself the monstrous precipice of your eyes. Narcissus dances? But it is something else besides vanity, egoism, and love of self that is at stake. Is it Death itself? Dance alone, then. Pale, livid, anxious to please or displease your image: but it is your image that will dance for you.

If your love, as well as your skill and cleverness, are great enough to reveal the secret possibilities of the wire, if the precision of your gestures is perfect, it will hurry to meet your foot (clothed in leather): it is not you who will dance, it is the wire. But if it is the wire that dances motionless, and if it is your image that it makes leap, where, then, will you be?

Death—the Death of which I speak to you is not the one that will follow your fall, but the one that precedes your appearance on the wire. It is before climbing onto it that you die. The one who dances will be dead—bent on every beauty, capable of them all. When you appear, a pallor—no, I am not speaking of fear, but of its opposite, of an invincible audacity—a pallor will cover you. Despite your makeup and your sequins, you will be pale, your soul livid. That is when your precision will be perfect. Since nothing more attaches you to the ground, you will be able to dance without falling. But be careful to die before appearing, so that a dead man dances on the wire.

And your wound, where is it?

I wonder where it resides, where the secret wound is hidden where every man runs to take refuge if his pride is hurt, when he is wounded? This wound—which thus becomes the innermost core—it is this wound he will inflate, fill. Every man knows how to reach it, to the point of becoming this wound itself a sort of secret, painful heart.

If we look, with a quick and greedy eye, at the man or woman[1] going by—or the dog, or bird, or jalopy—the very quickness of our gaze will reveal to us, neatly, what this wound is into which they withdraw when there is danger. What am I saying? They are there already, gaining through it—whose form they have taken—and for it, solitude: they exist entirely in the sluggishness of shoulder they pretend is themselves, their whole life flows into a mean fold of the mouth and against which they can do nothing, and want to do nothing, since it is through it that they know this absolute, incommunicable solitude—this castle of the soul—in order to be this solitude itself. For the tightrope walker of whom I speak, it is visible in his sad gaze, which has to reflect images of an unforgettably wretched childhood in which he knew he was abandoned.

It is into this wound—incurable, since it is himself—and into this solitude that he must throw himself, it is there he will be able to discover the strength, the audacity, and the skill necessary to his art.

I ask you for a little attention. Look: to surrender yourself better to Death, to make it live in you with the most rigorous precision, you will have to keep yourself in perfect health. The least illness would restore you to our life. It would be broken, this block of absence that you are going to become.

A sort of humidity with its patches of mildew would over-
come you. Watch over your health.

*If I advise him to avoid luxury in his private life, if I
advise him to be a little filthy, to wear shapeless clothes,
worn-out shoes, it is so that, at night, in the arena, the
change of scene may be greater, so that all the day's hope
may find itself exalted by the approach of the show, so
that from this very distance, from an apparent wretched-
ness to the most splendid apparition, would arise a tension
such that the dance will be like a gunshot or a cry, it is
because the reality of the Circus depends on this meta-
morphosis of dust into gold dust, but above all, it is because
the one who has to revive this admirable image must be
dead, or, if you prefer, must drag himself along the ground
like the last, the most pitiful of humans. I would even go
so far as to advise him to limp, to cover himself with rags,
with lice, and to stink. His person should be more and
more diminished to let this image of which I speak, in-
habited by a dead man, sparkle ever more brilliantly.
He should exist finally only in his appearance.*

It goes without saying that I did not mean to say that an
acrobat who works eight or ten meters above ground must
leave things to God (to the Virgin, tightrope walkers) and
should pray and cross himself before entering the arena, for
death is in the tent. As if to a poet, I was speaking to the
artist alone. If you danced one meter above the carpet, my
injunction would be the same. It is a question, you under-
stand, of deadly solitude, of that desperate and brilliant
region where the artist operates.

I will add, though, that you must risk an actual, physical

death. The dramatic art of the Circus requires it. It is, along with poetry, war, and bullfighting, one of the only cruel games that remain. Danger has its reason: it will force your muscles to achieve a perfect precision—the least mistake would cause your fall, with injuries or death—and this precision will be the beauty of your dance. Reason thus: a blunderer on the wire does the midair somersault, he misses and kills himself, the audience is not too surprised, it was expecting it, it was almost hoping for it. You must know how to dance so beautifully, with such pure gestures, in order to seem precious and rare; thus, when you get ready to make the midair somersault, the public will be anxious, will be almost indignant that such a graceful being risks death. But you succeed in the somersault and return to the wire, while the spectators cheer you, for your skill consists in saving a very precious dancer from an indecent death.

If he dreams, when he is alone, and if he dreams about himself, probably he sees himself in his glory, and no doubt he tried a hundred, a thousand times to grasp his future image: himself on the wire on a triumphant night. So he endeavors to represent himself to himself as he would like to be. And it is to this becoming what he would like to be, how he dreams himself, that he applies himself. Of course this dreamed-of image is far from what he will be on the actual wire. But that is what he seeks: later on to resemble this image of him that he invents for himself today. And so that, once he has appeared on the steel wire, there will remain in the audience's memory only an image identical to the one he invents for himself today. Curious project: to dream himself, to make this dream perceptible that will become a dream once again, in other heads!

So it is frightening death, the frightening monster that lies in wait for you, that is conquered by the Death of which I told you.

Your makeup? Excessive. Extravagant. Make it elongate your eyes all the way to your hair. Your nails will be painted. Who, if he is normal and clear-headed, would walk on a wire or express himself in verse? It is too crazy. Man or woman? Definitely a monster. Rather than aggravate the singularity of such an exercise, makeup will lessen it: in fact, it makes more sense if it's an adorned, gilded, painted, finally equivocal being who walks there, without a balancing pole, where roofers or lawyers would never think of going.

Made-up, then, sumptuously, to the point of provoking nausea at the sight of him. During the first of your turns on the wire, they'll understand that this monster with mauve eyelids could dance nowhere but there. No doubt, they will tell themselves, it is this peculiarity that puts him on a wire, it is that elongated eye, those painted cheeks, those golden nails that force him to be there, where we—thank God!—will never go.

I am going to try to make myself understood better.

To acquire that absolute solitude he needs if he wants to complete his work—drawn from a nothingness that it will both fill in and make perceptible—the poet can put himself in danger in some posture that will be the riskiest for him. Cruelly, he repels any curious person, any friend, any appeal that might try to incline his work toward the world. If he likes, he can go about it this way: around him he leaves such

a sickening, such a black smell that he finds himself lost in it, half-asphyxiated by it himself. People flee from him. He is alone. His seeming curse will allow him all daring innovations, since no gaze troubles him. He moves in an element that is like death, like the desert. His speech awakens no echo. Since it must utter what is addressed to no one and no longer has to be understood by anything that is living, it is a necessity that is not required by life, but by the death that commands him.

Solitude, I have told you, could be granted to you only by the presence of the audience, so you must go about it differently and have recourse to another procedure. Artificially, by an effect of your will, you should compel this imperviousness toward the world to enter you. As its waves mount up—like the coldness starting in Socrates' feet, making its way up to his legs, his thighs, his stomach—their coldness seizes your heart and freezes it.—No, no, again no, you are not there to amuse the public, but to fascinate it.

Confess that they would experience a curious impression—it would be astonishment, panic—if tonight they managed to behold a corpse walking on the high wire!

"Their coldness seizes your heart and freezes it . . ." but—and this is the most mysterious thing of all—a sort of steam must at the same time come from you, a light steam that does not blur your angles, letting us know that in your center, a hearth keeps feeding that glacial death that entered you through your feet.

And your costume? At once chaste and provocative. It is the skintight body stocking of the Circus, in blood-red jersey. It outlines your musculature exactly, it sheathes you, it gloves

you, but from the collar—open in a circle, cut clean, as if the executioner were going to behead you tonight—from the collar to your hip, a sash, also red, but from which float tassels—fringed with gold. Red tennis shoes, sash, belt, collar's trim, ribbons under the knee, are embroidered with gold sequins. So that you sparkle, of course, but especially so that you lose in the sawdust, when you go from your dressing room to the arena, a few badly-sewn sequins, delicate symbols of the Circus. During the daytime, when you go to the grocer's, a few fall from your hair. Sweat has stuck one to your shoulder.

The bulge accentuated in the bodysuit, where your balls are enclosed, will be embroidered with a gold dragon.

I tell him about Camilla Meyer—but I also want to tell him who that splendid Mexican was, Con Colléano, and how he danced!—Camilla Meyer was a German woman. When I saw her, she was about forty years old. In Marseille, she had set up her wire thirty meters above the pavement, in the courtyard of the Vieux-Port. It was night. Spotlights lit up the horizontal wire thirty meters high. To reach it, she climbed up on a slanting wire two hundred meters long that started at the ground. Arriving halfway up this slope, to rest, she put one knee on the wire, and kept the balancing-pole on her thigh. Her son (he was about sixteen), who was waiting for her on a little platform, brought a chair to the middle of the wire, and Camilla Meyer, who was coming from the other side, arrived on the horizontal wire. She took this chair, which rested on the wire with only two of its feet, and she sat down on it. Alone. She came down from it, alone.... Below, beneath her, all heads were lowered, hands hiding

their eyes. Thus, the audience refused this politeness to the acrobat: to make the effort to look steadily at her when she brushes with death.

—And you, he said to me, what were you doing?

—I was watching. To help her, to salute her because she had led death to the edges of night, to accompany her in her fall and in her death.

If you fall, you will deserve the most conventional funeral oration: puddle of gold and blood, pool where the setting sun....You should expect nothing else. The circus is all convention.

For your entrance into the arena, avoid the pretentious walk. You enter: it is a series of leaps, of midair somersaults, of twirls, cartwheels, that bring you to the foot of your contrivance, onto which you climb, dancing. With your very first leap—begun in the wings—people should know already that they will go from wonder to wonder.

And dance!

But with a hard-on. Your body will have the arrogant vigor of a congested, irritated sex. That is why I advise you to dance in front of your image and to be in love with it. You can't get out of it: it is Narcissus who is dancing. But this dance is only your body's attempt to identify itself with your image as the spectator experiences it. You are no longer just mechanical and harmonious perfection: a wave of heat comes from you and warms us. Your stomach burns. Still, do not dance for us, but for you. It was not a whore we came to see

at the Circus, but a solitary lover in pursuit of his image who saves himself and faints on a metal wire. And always in the infernal land. So it is this solitude that will fascinate us.

Among other instants, the Spanish crowd awaits the one when the bull, with a thrust of his horn, will take the stitches out of the torero's pants: after the tear, the sex and blood. Stupidity of nudity that doesn't try to show or exalt a wound! So it is a body stocking the tightrope walker will have to wear, for he must be clothed. It will be illustrated: embroidered suns, stars, irises, birds . . . a body suit to protect the acrobat against the hardness of the public's gaze and so that an accident can be possible, so that one night, the body suit can give way, get torn.

Must it be said? I would want the tightrope walker to live during the day disguised as an old, toothless female tramp, with a gray wig: seeing her, one would know what athlete reposes beneath the rags, and one would respect such a great distance of day from night. To appear in the evening! And he, the tightrope walker, no longer knowing who his privileged self might be: the seedy female tramp, or the gleaming loner? Or the perpetual movement from her to him?

Why dance tonight? Why leap, bound beneath the spotlights eight meters above the floor, on a wire? Because you must find yourself. Both game and hunter, tonight you flushed yourself out, you flee from yourself and hunt for yourself. Where were you, then, before entering the arena? Sadly dispersed in daily actions, you did not exist. Under its spotlights, you experience the necessity of order. Every night, for

you alone, you will run on the wire, twist yourself on it, writhe on it in search of the harmonious being, scattered and lost in the thicket of your familiar gestures: tying your shoelace, blowing your nose, scratching yourself, buying soap.... But you only approach and grasp yourself for an instant. And always in that deadly, white solitude.

Your wire, though—I'll come back to it—do not forget that it is to its virtues that you owe your grace. To your own too, of course, but in order to discover and reveal its own. The game must be unbecoming to neither: play with it. Tease it with your toe, surprise it with your heel. Face one another, do not fear cruelty: sharp, it will make you sparkle. But always take care never to lose the most exquisite courtesy.

Know over whom you triumph. Over us, but...your dance will be hateful.

One is not an artist unless a great unhappiness is mixed in. Hatred against what god? And why conquer him?

The hunt on the wire, the pursuit of your image, and those arrows you riddle it with without touching it, and wound it and make it shine—it is a celebration. If you reach it, this image, it is the Celebration.

I am experiencing a strange thirst, I want to drink, that is to suffer, or to drink so that drunkenness comes from the suffering that a celebration would be. You wouldn't know

how to be unhappy through illness, through hunger, through prison, since nothing forces you to be so, you have to be it through your art. What do we—you or I—care about a good acrobat: you will be that glowing wonder, you who burn, who last a few minutes. You burn. On your wire, you are lightning. Or if you like, a solitary dancer. Lit up by who knows what that illumines you, consumes you, it is a terrible misery that makes you dance. The audience? It sees nothing but fire, and, thinking you are playing, unaware that you are the arsonist, it applauds the fire.

Have a hard-on, and make others have one. This heat that comes from you and shines, it is your desire for yourself—or for your image—never satisfied.

Gothic legends [in fact, a short opera by Jules Massenet, *Le jongleur de Notre-Dame*, very popular in Genet's childhood, deals with this—*Trans.*] speak of street acrobats who, having nothing else, offered their tumbles to the Virgin. In front of the cathedral they danced. I do not know to what god you will address your games of skill, but you must have one. The one, perhaps, that you make exist for an hour and for the dance. Before your entrance in the arena, you were a man mingling with the throng in the wings. Nothing distinguished you from the other acrobats, jugglers, trapeze artists, horse-women, stage hands, clowns.—Nothing, except that sadness already in your eyes, and do not chase it away, that would be to kick all poetry out of the door of your face!—God does not yet exist for anyone...you arrange your dressing gown, you brush your teeth....Your gestures can be repeated...

Money? Dough? It must be earned. And until he dies of

*it, the tightrope walker must rake it in.... One way or
another, he will have to disorganize his life. That is when
money can be useful, bringing a sort of rottenness that
can pollute the calmest soul. A lot, a whole lot of dough!
A load of it! A vile amount! And then to let it pile up in
a corner of your shack, never touching it, wiping your ass
with your finger. As night approaches, to wake up, tear
yourself away from this evil, and in the evening, dance
on the wire.*

I say to him again:

—You will have to work to become famous...

—Why?

—To hurt.

—Do I have to earn so much dough?

*—You have to. On your metal wire you'll appear, and
a rain of gold will shower down on you. But since noth-
ing interests you but your dance, you will rot during the
daytime.*

*He should rot then in a way, a stench should crush
him, sicken him, which fades away at the first trumpet
call of evening.*

But you enter. If you dance for the public, it will know
it, you'll be lost. There's one of your regulars. No longer
fascinated by you, he'll sit heavily within himself, you'll never
be able to tear him away from himself.

You enter, and you are alone. Seemingly, for God is there.
He comes from I don't know where and perhaps you brought
him when you entered, or solitude revives him, it's all the
same. It is for him that you hunt your image. You dance.
Face set. Gestures precise, bearing true. Impossible to repeat

them, or you die for eternity. Severe and pale, dance, and, if you can, with your eyes closed.

Of what God am I speaking to you? I wonder. But he is absence of criticism and absolute judgment. He sees your quest. Either he accepts you and you sparkle, or he turns away. If you have chosen to dance before him alone, you cannot escape the precision of your articulate language, of which you become prisoner: you cannot fall.

Might God then be only the sum of all the possibilities of your will applied to your body on this metal wire? Divine possibilities!

When you practice, your midair somersault sometimes eludes you. Do not be afraid of considering your somersaults as so many rebellious animals that it is your job to tame. This somersault is within you, untamed, scattered—and thus unhappy. Do what you must to give it human form.

"A red body stocking with stars." I wanted the most traditional of costumes for you so that you could more easily wander into your image, and if you like, carry off your metal wire so that you both might finally disappear—but you can also, on this narrow path that comes from nowhere and goes nowhere—its six meters' length are an infinite line and a cage—give the performance of a tragedy.

*

And, who knows? If you fall off the wire? Stretcher bearers will carry you off. The orchestra will play. They'll bring in the tigers, or the horsewoman.

> *Like the theater, the circus takes place in the evening, as night approaches, but it can also be given in full daylight.*
>
> *If we go to the theater, it is to penetrate into the hall, into the anteroom of that precarious death that sleep will be. For it is a Celebration that will take place at close of day, the most serious one, the last one, something very close to our funeral. When the curtain rises, we enter a place where infernal replicas are being prepared. It is evening so that it can be pure (this celebration), so that it can unfold with no danger of being interrupted by a thought, by a practical requirement that could ruin it . . .*

. .

> *But the Circus! It needs keen, total attention.*
>
> *It is not our celebration that is presented. It is a game of skill that requires us to remain awake.*

The audience—which allows you to exist, without it you would never have the solitude I spoke about—the audience is the animal that you will finally stab. Your perfection, as well as your boldness, will, during the time you appear, annihilate it.

Rudeness of the audience: during your most dangerous movements, they will close their eyes. They close their eyes when in order to dazzle them you brush with death.

*

That brings me to say that one must love the Circus and despise the world. An enormous beast, brought back from diluvian times, places itself massively over the cities: we go in, and the monster is full of mechanical and cruel wonders: horsewomen, clowns, lions and their tamer, a magician, a juggler, German trapeze artists, a horse who speaks and counts, and you.

All of you are the remnants of a mythical age. You come from very far away. Your ancestors ate crushed glass, fire, they charmed serpents, doves, they juggled with eggs, they made a council of horses converse.

You are not ready for our world and its logic. So you must accept this misery: to live at night on the illusion of your mortal performances. During the day, you linger fearful at the circus door—not daring to enter our life—too firmly held back by the powers of the circus, which are the powers of death. Never leave this enormous canvas womb.

Outside is discordant noise, disorder: inside, it is the genealogical certainty that comes from millennia, the security of knowing one is connected in a sort of factory where precise rules are made that serve as the solemn exposition of yourselves, who prepare the Show. You live only for the Show. Not the one that fathers and mothers treat themselves to by paying. I'm speaking of your illumination of those few minutes. Obscurely, in the flanks of the monster, you all understood that each of us must strive for that: to try to appear to oneself in one's apotheosis. It is into yourself, finally, that

for a few minutes the performance changes you. Your brief tomb illuminates us. You are enclosed within it while at the same time your image keeps escaping from it. The wonder is that you have the power to fix yourself there, both in the arena and in heaven, in the form of a constellation. This privilege is reserved for few heroes.

But, for ten seconds—is that a little?—you shine.

During your practice, do not despair at having forgotten your skill. You begin by showing much ability, but shortly you must give up hope for the wire, the somersaults, the Circus, and the dance.

You will know a bitter period—a sort of Hell—and it is after this passage through the dark forest that you will rise again, master of your art.

One of the most moving mysteries is this: after a brilliant period, every artist will cross a desperate land, risking losing his reason and his mastery. If he emerges victorious . . .

Your somersaults—do not be afraid of thinking of them as a herd of animals. In you, they lived in a wild state. Uncertain of themselves, they tore each other up, mutilated each other, or mated at random. Pacify your herd of leaps, somersaults, and turns. Each one should live intelligently with the other. Proceed, if you like, to crossbreeding, but with care, not with the randomness of caprice. Now you are shepherd of a flock of beasts that up till now had been disordered and pointless. Thanks to your charms, they are submissive and skillful. Your somersaults, your turns, your leaps were in you, and they knew nothing of that; thanks to your charms, they know that they exist and that they are you, making yourself renowned.

*

These are pointless, clumsy pieces of advice I give you. No one could follow them. But I wanted nothing else: than to write a poem about this art whose heat would rise to your cheeks. It was a question of inflaming you, not teaching you

Translated by Charlotte Mandell

NOTES

1. Episode of the Rose. The Image has no rose in his belt. With his teeth, the dancer playing the role of the Image tears away this rose, runs off, and keeps it in his mouth.

FRAGMENTS...

1. "Strange loves! A twilight smell isolates you. But it is less the disheveled monster of your interlaced bodies than its image multiplied in the mirrors of a bordello—or your delicate brain?—that troubles you! Dripping with sweat, you climb back up from those absurdly distant lands: you had capsized in yourself where flight is surest, your drunkenness swelling to the point of exploding—from your sole and reciprocal exhalation. Loves, name these games of reflections that are exhausted, shouted out endlessly on the walls of gilded rooms."

Thus speaks an oblique reason that, fascinated, watches death appear in each accident. Name, exhaust these games and come back to the air. You recognize and accept the smell of the pieces of shit that, hemming it, remain beneath the index fingernail. It is slight and sad, dawn of sterile loves. Not nauseous, but indicative of exception. "Amuse yourself when others are bored stiff" is the expression of a regret. Your memory preserves it, so you float in a halo of subtle shame and reprobation: the most despised of the places of the body is not ennobled, but cherished. Such clear, such pure faces, if my cruelty doesn't make tears come to them—and snot: it's this sweet, sad smell I want them to be enveloped in when they go away.

"If I tear out a piece, yes, like an aniseed..." but if I cram your shit, handsome monsters, it is not into you that I plunge it, it is from you that I escape for your image, infinitely multiplied, where I wander.

2. By the eagle, transport of a lamb: in the air, his four feet suddenly useless. The audacity of theft is in the fixed, round eye! The most consoling image, and for us, this evening, the most effective will be the idea of Ganymede lifted by the bird. Stretched out on the unmade bed, the adolescent finally abandons himself and lets the slow, majestic wingspan develop. Brought to earth, bitten on the neck, calmed gently but profoundly by the god, he is ravished. Lightning! Thunderbolts! No. The eagle is embroidered on a shroud where the child expires. "Come, you will be the cupbearer of the gods." Tousled, scarcely intimidated, you enter heaven to serve the Queers.

3. Even though my entire activity as a thief was only the visible stylization, led into the world of action, of an erotic theme, so much so that I went about it in a poetic aura, that is, gratuitous and useless, my lovers, unable to be anything but apparent supports, were capricious ornaments without practical value, with no other virtue than that of uselessness and luxury: my thieves, my sailors, my soldiers, my criminals? no: their image.

4. I will call "real" any event that can be the starting point for a morality, that is to say, for a rule on which the relationships of all men rest. The word that seems able to express them might be the word "equity." An unreal attitude is one that logically leads to aesthetics.

5. I no longer ignore the fact that from one single fact that cannot be led to a system of morality, you must extract, if you are coherent, an aesthetics.

6. With my cold chisel, words, detached from language, neat blocks, are also tombs. They hold prisoner the confused nostalgia of an action that men accomplished and that words, bloody at the time, mean to name. Here they are silent. The deed was accomplished elsewhere, in mythical times. Words preserve only a faint light from those times. Nothing more imprecise than the word "ceremony," except for whatever it still retains of rigor, order, and earthly power. Words also get their qualities from those powers that consecrate them and to which they refer, but which would give so many more powers to the powerful if words referred to an order that was consecrated by song.

7. The words used for my construction lose their power of communication. They are finite, hemmed in as much as possible by their own

contours, and I will make sure that they refer poorly to the objects they name, that of these objects there will remain captive only the most ghostly appearance, but that the word is colored with my anguish, and that, from the relationship of each of them, tomb without contents, there rises up an abstract construct possessing force and meaning.

8. Isn't the least wretched thing the pederast can do, if he picks a boyfriend, to impose on him a fate he can't take on in his own body? No doubt this is still a "reflective" way to live, to choose a reflection for oneself—or an earthly representation—or a delegate—that one projects onto the world when one thinks it is himself, but, aided by some nobility of the soul, as the boyfriend awakens, suffers, lives on the earth, the pederast must strictly try to annihilate himself till he is nothing but a beam of light guiding his delegate, a breath inspiring him, the soul of a body and of a soul, to the point of being only an "idea of infinite misery." Knowing how vain are the prestigious rags of the world, what I have just called "nobility" still seems base when you use it to cover the shoulders—even if they are muscular— of an adolescent. It is to offer him an empty power. If not to kill him, what can I demand from a friend whose love I need—and with him, the world's recognition?

9. Sign of pederast passion: it is the possession of an object that will have no other fate than the fate required by the lover. The loved one becomes an object charged, in this world, with representing death (the lover). (Sign of the obsession of the Emperor Heliogabalus whose coachman wears the attributes—robe, cloak, necklace—of power—when the Emperor lives alone, obscure, secret, in an empty room in the palace.) The lover charges a servant with living in his place. Not living, appearing. Neither one nor the other lives. The loved one does not adorn the lover, he "reproduces" him. The loved one is then sterilized if he lives unhealthily according to this obsession that haunts the lover.

10. There are enough lost children, I tell myself I will steal one of them. Let him live in my place. Let him take charge of my fate. What fate, if I want to be dead? Let him take charge of my death. Absurd scenario: sealed in a vault, pensive, determined, desperate—with my love, I direct my weak ambassador among the living. He will live my

hatred. Paradoxically, my rupture is perpetuated. Will he have to love me? First he must bear evil: a criminal child will travel through the world. Viciously turned on him, it is from me he awaits a spark. If he kills, he is silent: prison, scaffold, hard labor, so many deaths he will live in my place. But to accept our mortal injunction this way, one must oneself be dead. The lost child was dead already. His secret carnival was not ours, we couldn't recognize it, nor he ours. Alas, it is only through love that he could obey our orders. And we, will we call "love" this rigor that comes from the prison cell that forced us to lead him to death, to invent evils for him, a moral code, the habits of death among men?

THE TIGHTROPE WALKER

1. The most moving are the ones that withdraw into a sign of grotesque derision: a hairstyle, a certain kind of moustache, rings, shoes.... For an instant, their entire life rushes there, and derail sparkles: suddenly, it goes out: that is because all the glory that was brought there has just withdrawn into that secret region, finally bringing solitude.

OTHER NEW YORK REVIEW CLASSICS

For a complete list of titles, visit www.nyrb.com or write to:
Catalog Requests, NYRB, 435 Hudson Street, New York, NY 10014